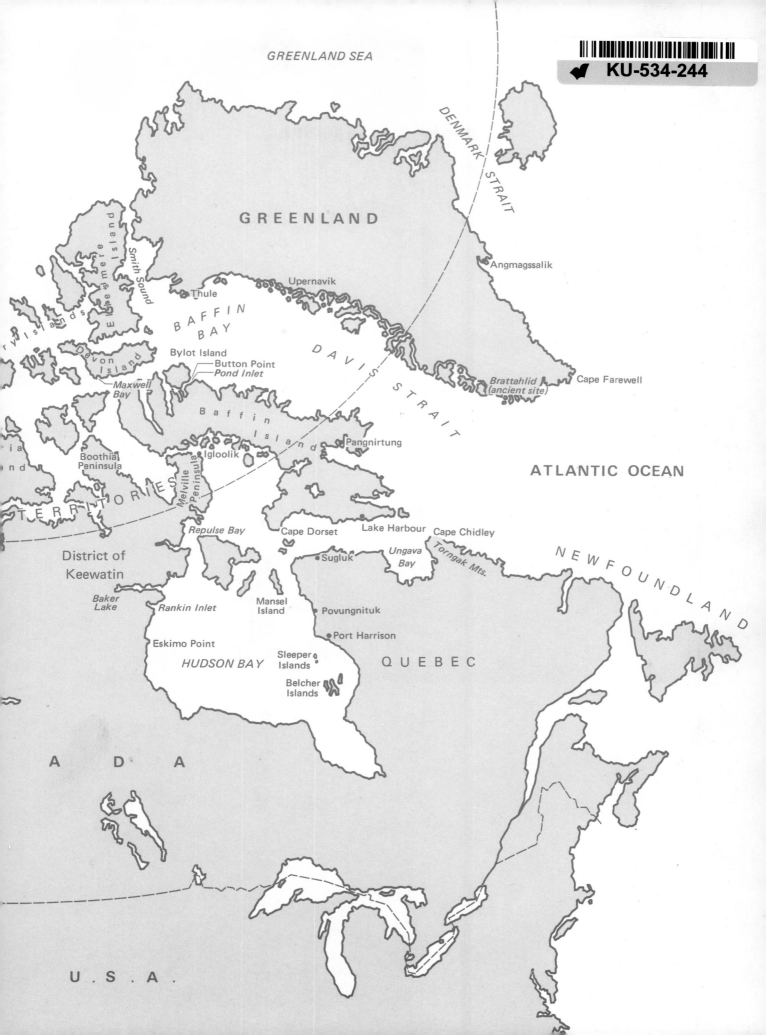

Ian Reekie

# Eskimo Art

# Eskimo Art

## Cottie Burland

# Hamlyn

London · New York · Sydney · Toronto

1 half-title page: **Caribou** by Angosaglo and Aningnerk. Print.
Cape Dorset, N.W.T., 1971
2 title page: **Fight for wife** by Kalvak. Print. Holman, N.W.T.,
1973
3 contents page: **Surprise** by Kalvak. Print. Holman, N.W.T., 1973

Published by
The Hamlyn Publishing Group Limited
London · New York · Sydney · Toronto
Hamlyn House, Feltham, Middlesex, England
© copyright The Hamlyn Publishing Group Limited 1973

ISBN 0 600 33083 4

Text set in 'Monophoto' Ehrhardt by
London Filmsetters Limited
Printed in England by
Sir Joseph Causton and Sons Limited

# Contents

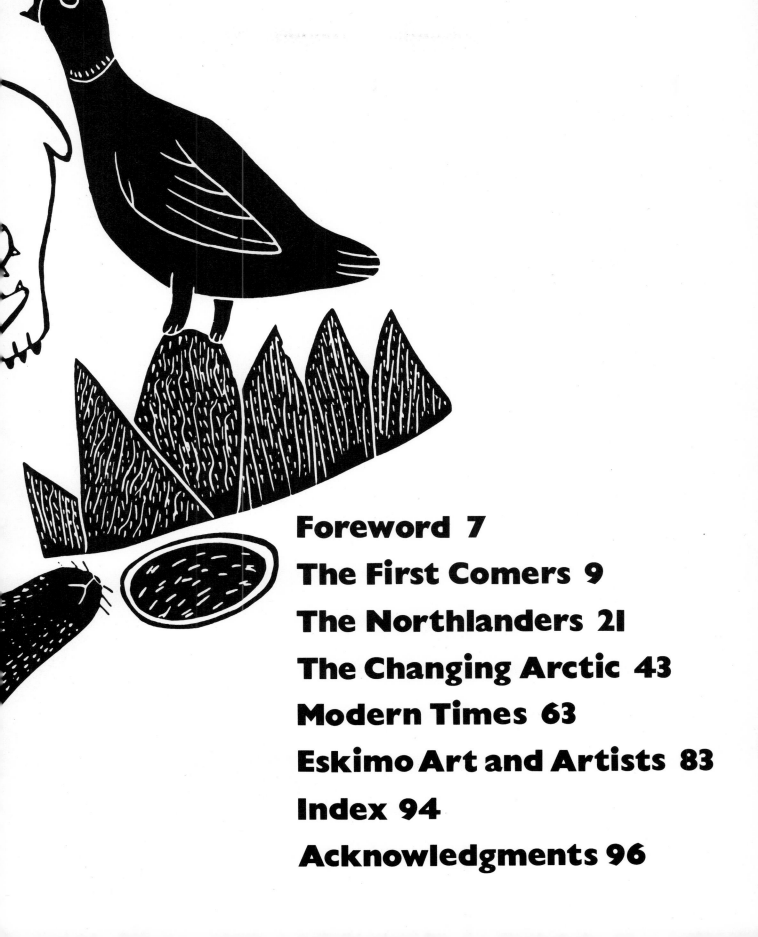

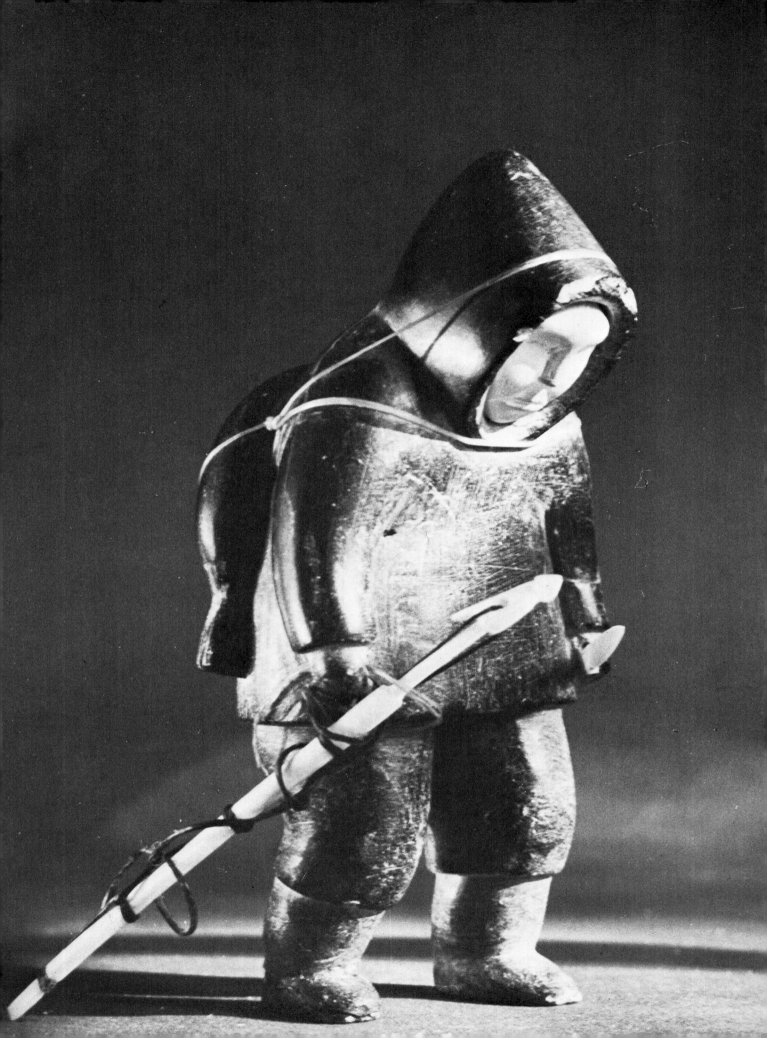

# Foreword

No human race has won its living in a harsher environment than the hundred thousand or so hunters of the arctic ice. No people have been so richly reported, or so little understood, as these folk. Even the name given to them was a misnomer. In 1611 the word Escomminquois was used by the explorer Biard who had heard the Chippewa Indians talk of a northern group of ice hunters as Ashquimec which means, 'They eat raw flesh'. This was often true enough, but it was not the real name of those fur-clad hunters; they called themselves simply Inuit which means, 'people'. The Eskimos had been separated from most other humans for thousands of years and were justified in thinking that they were the only people on the earth.

In talking of the art of the Eskimos we are dealing with an idea which was not part of their normal life. They made many things, often of great beauty, but they were to them no more than practical objects. A snow knife or a bow drill was a tool, although sometimes its smooth surfaces were ornamented by a few scenes of hunting in order to make it lucky. Toggles were carved to resemble the heads of seals and polar bears because these were the animals desired by the hunter for his family dinner. Life was hard, and time moved uncertainly, from the rush of energy in a hunt to long hours of waiting by a seal blow-hole in the ice. In the long nights of winter when the sun was not seen for months there were moonless or stormy times when equipment was made, and sometimes the worker produced objects of astonishing artistic value, just because he was making a useful object and decorating it without any self-consciousness.

In recent years the world of the Eskimo has changed radically. New weapons for the hunter, new propulsion for boats and sledges, and new concentrations of population have meant new needs. A market has opened for the sale of Eskimo carvings; a friend came among the people to instruct them how to expand their simple graphic art into the production of beautiful lithographic prints. The natural ability of the people has made possible a new source of income. Not all Eskimos have the time or the inclination to make such works of art, and a new phenomenon has arisen in their social structure: the artist as a professional. The Eskimos now stand at a cross-roads of culture, for the old life has nearly disappeared. They know well that ancestral ways are going for ever. Many realise the value of entering a world culture with its education, trade and technology. The northland has been burst wide open for its oil and its strategic potential. Its people have not just lost heart and died, but being intelligent and capable they have faced their problems and found solutions. They have not despised the white man but have accepted offers of help and, with much reticence, have adopted new ways.

It is now a moot point whether the old ways of the Eskimos have any meaning. They may even face the day when their old world will be abandoned for a more hospitable environment. All is changing, but the children of the ancient hunters have carried on some traditions and still make beauty. However, to understand this world of the modern Eskimo artist we must make a voyage into the past, indeed to a very distant past when our own ancestors were also fighting the perils of an Ice Age.

---

4 **Hunter returning with seal.** Soapstone (12 cm high). Cut at Povungnituk, Quebec, about 1955. (Collection: Dr Helge Larsen, Copenhagen)

# The First Comers

The earliest date for the presence of humans in the arctic comes from Alaska, where a cache of stone tools has been found in association with fragments of wood. The radio-carbon date given to this find is twenty-eight thousand years ago. It is highly probable that a few families were in the American continent even before then, but this is the earliest trace we have of man in the world of the far north. Conditions then were harsher than they are now. It was the height of the last glaciation, when so much ice was locked up in the enormous ice caps around the poles that the level of the oceans was nearly two hundred feet below the present sea level. It is almost impossible to understand the conditions in which a family of advanced Stone Age hunters crossed over solid land where now the waters of the Bering Strait achieve periodic liquidity. There was, in fact, no mass migration, because hunting folk cannot find enough food if they travel in groups of more than a few families. Nor were they naked savages; they must have had satisfactory garments of fur, and some means of controlling fire. A few bones from similar levels show that physically the earliest hunters were not radically different from the Eskimos of recent times.

Unfortunately, the immense period of elapsed time has destroyed all their materials except the sharp-edged blades flaked from silicious rock. But the skill of the craftsman who made the blades is without doubt. They are not relics of a truly primitive people, but of some unknown tribe whose hunters carried really efficient knives and spears, where the stone flakes had been worked around the edges by pressure flaking to give symmetry and a razor-sharp cutting edge. Those hunters in the arctic of long ago were no whit inferior in their skill with stone than their contemporaries in Europe. They were the precursors of the peoples who made the Denbigh flint culture in Alaska and whose flaked-stone tools extend far along the Canadian arctic and even to Greenland. In Canada their work is simply labelled pre-Dorset. Radio-carbon dating has given us the impression that they moved from west to east, and that they lived more than five thousand years ago. There exist a few of their bone and ivory objects, but nothing is yet reported which can be described as a work of artistic quality. The stone blades have been found in excavations near areas inhabited in recent times by the Eskimos, but so far no really good evidence about the house types and the way of life of these makers of flint tools of great efficiency has been discovered. Nevertheless, they must have had some shelters. It was in their time too that the climate began to ameliorate and the oceans to melt.

By some three thousand years ago there was a change. Whether it was a change of population, with more tribes moving in from Siberia, or simply a development by the local populace we do not know. But the Old Bering Sea culture appeared in Alaska and continued around the shores of the Arctic Ocean, where, after about two centuries, it reached Greenland. In the Arctic Ocean regions it is known as the Dorset culture, and there it differs somewhat from the Bering Strait region because of the more restricted ecology where there was little access to the open sea.

The Old Bering Sea culture left some specimens of art in ivory. Styles developed as time went on and pieces became much more rich in design, evolving towards the Ipiutak culture of Alaska where decorative art was much used in beautifying the surface of weapons and tools. The delicacy of this Alaskan art-form is exquisite, with its sweeping curves and spirals incised quite lightly over the curved surfaces of the ivory.

The characteristic dwelling of the Bering Strait people was the earth house, a pit dug in the earth, not very deep, but sufficient to allow a pool of warm air to accumulate. Around this, walls were erected, mostly of wood in the south, and in the north of whale ribs and any other large bones to be found nearby. Presumably these walls were fortified by layers of skin covered with sods of earth. From remains in the house ruins it has been deduced that the people of this early period were, like the later Eskimos, seasonal hunters. That is, they spent the summer in skin tents going after the land animals, and in the winter returned to the coastal settlements for a period of ice hunting. It is probable that around the beginning of

5 **Old wooden dance mask** with flaring nostrils typical of the Dorset culture. From Point Barrow, Alaska. Acquired in 1909. (Horniman Museum, London)

the Christian era the climate was a few degrees warmer than at present, so hunting conditions were better.

On the shores of the Arctic Ocean, life was never easy. The only wood was driftwood, moving with currents in the summer. The Dorset culture people made themselves earth houses, often round and not rectangular like the Alaskan ones. They used whale ribs as supporting beams in great numbers, and must have spent much time in whale hunting with harpoons. They left no evidence of using the single-seater kayaks of later times, but took off on hunting expeditions in large skin-covered open boats, rather like curraghs, which they called umiaks. In all their settlements so far, only one small sledge made up of bones has been found. It appears that they had no dogs, and that this small sledge must have been

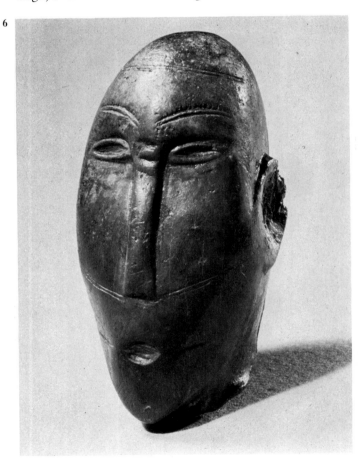

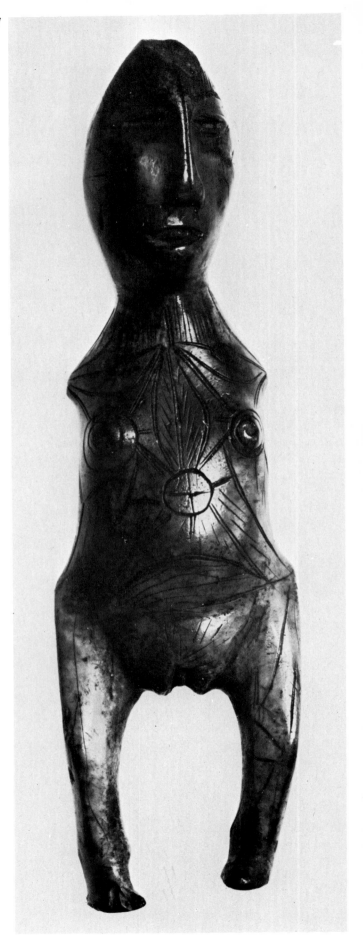

**6 Head made from walrus tusk,** broken off from body (8.3 cm high). From the Punuk Islands, Bering Sea. Prehistoric Okvik culture, about A.D. 0–500. (Danish National Museum, Copenhagen)

**7 Armless female figure.** Ivory. From the Punuk Islands, Bering Sea. Prehistoric Okvik culture, about A.D. 200. (University of Alaska Museum, College, Alaska)

**8 Mask made from carved pieces of walrus tusk.** The back is roughly finished and was probably nailed on to wood. Under the mouth two large pieces of jet have been inserted as labrets (lip plugs), and eighty cavities were apparently inlaid with jet. (16.4 cm high). Grave find from the Point Hope settlement, Alaska. Ipiutak culture, about A.D. 300–1000. (The American Museum of Natural History, New York)

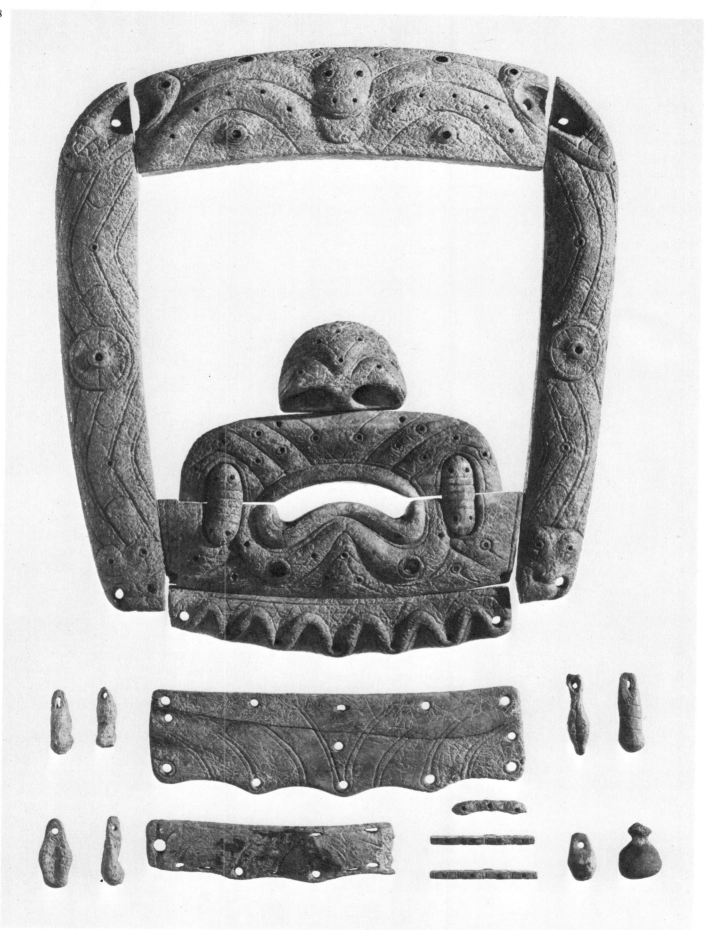

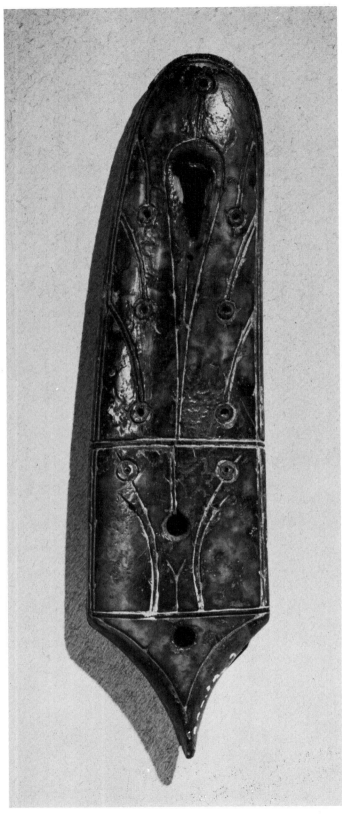

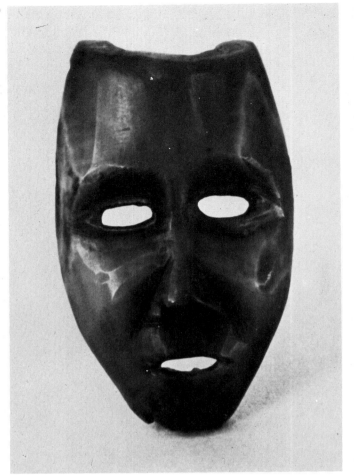

dragged by the hunter. From the limited number of excavations made in the remains of their villages it seems that most of the harvest of the hunter was carried on his back, or the backs of his wives.

The art styles of the Dorset culture are as distinct as those of the Alaskan Bering Sea and Ipiutak people. On the whole, Dorset material is strong and marked by rather coarse cutting, though the earliest known piece, a tiny ivory mask from Igloolik which has been radio-carbon dated to about 780 B.C., is a work of great delicacy and sensitivity. However, most Dorset art is marked by deep grooves across figures and masks, simple forms in the little figure carvings, and quite often an omission of arms because of the difficulty of carving such appendages. A good deal of carving in driftwood has survived. But we know nothing so far about Dorset culture clothing, except for a few lines on figures which suggest that anorak and trousers were standard, for among the Dorset people as with most Eskimos the figures are usually naked.

There are several Dorset culture combs known to us, and some have human faces carved on them. These faces have distinctly Eskimo features, though there is a strong tendency to depict exaggeratedly flaring nostrils. This may, however, be a representation of some spirit being. We can say

**9 Man's knife handle.** Ivory (14 cm long). The blade was probably made of slate. From the Punuk Islands, Bering Sea, about A.D. 1000–1200. (The Museum of Primitive Art, New York)

**10 Ivory masquette** (9 × 3.5 × 2 cm). From the Tyara site, Sugluk, Quebec. Dorset culture. (National Museum of Man, Ottawa)

**11 Woman with a top-knot.** Walrus tooth (8.1 cm high). From the Thule district, Greenland. Probably Dorset culture, about 700 B.C.–A.D. 1300. (Danish National Museum, Copenhagen)

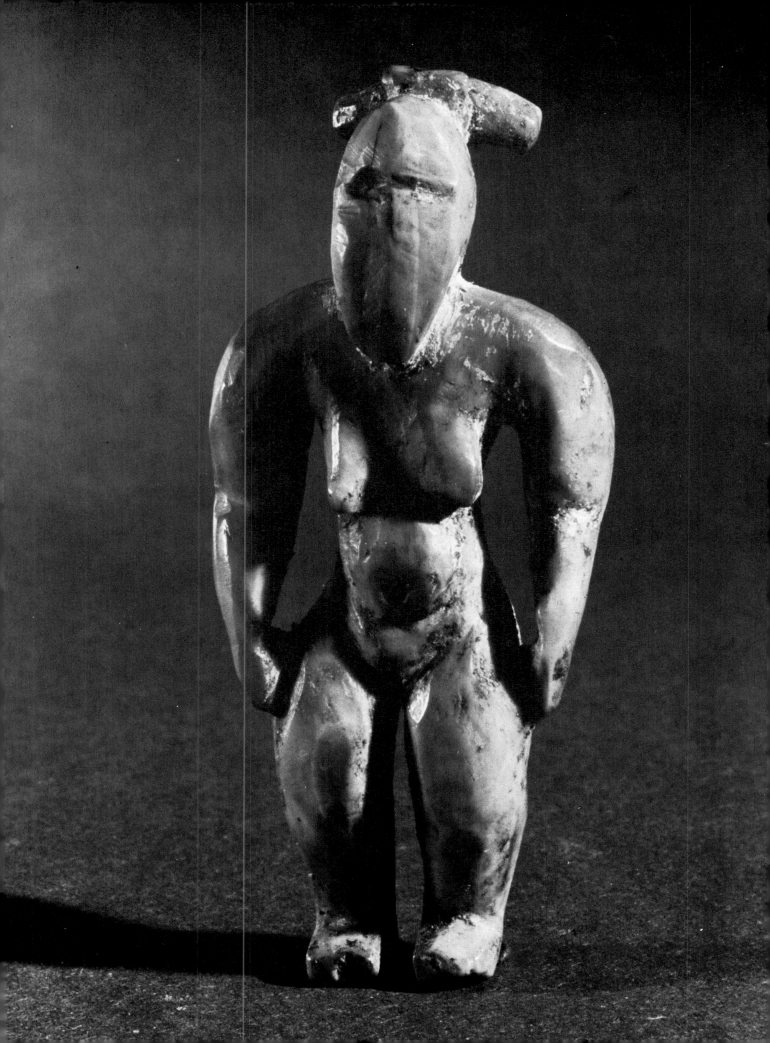

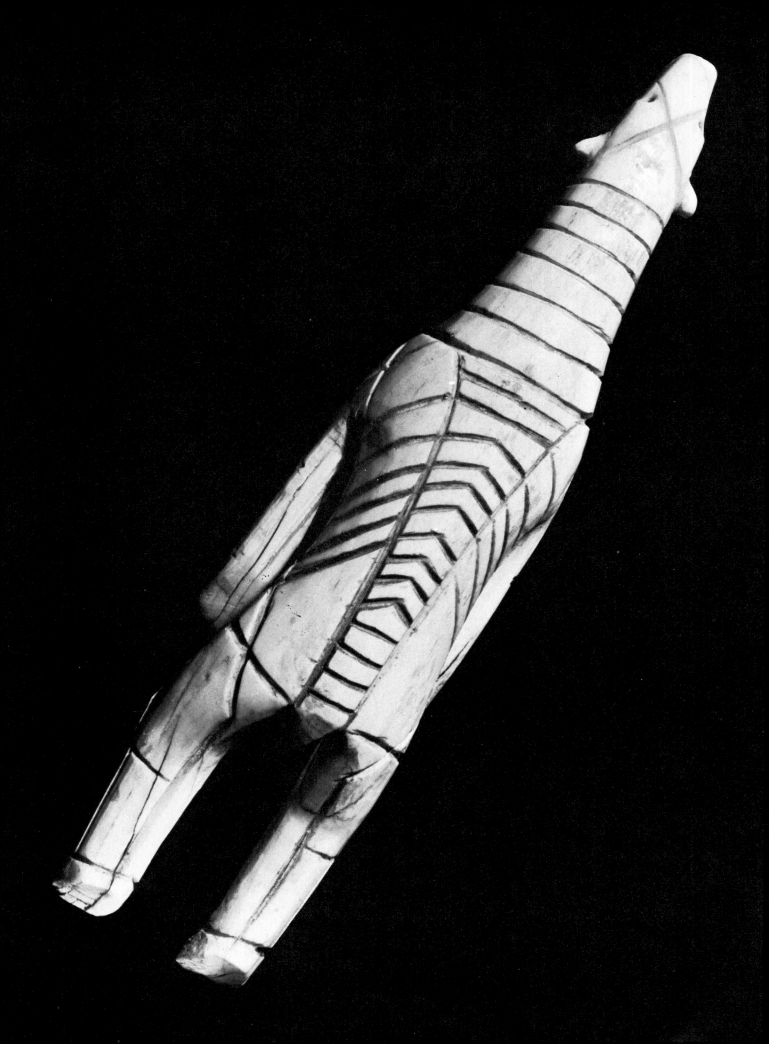

nothing about Dorset religion or language. There is nothing of certainty. Several ivories show bear-man figures, and some wooden masks have been found in recent years. The wooden masks, usually quite well carved, represent Eskimo facial types like the combs. It seems as if some shamanistic religion was expressed by these things; there even exist some ivory cases which are of a type known to have been used by Eskimo shamans in later times. (The shaman is a particular kind of 'medicine man' found in primitive societies who acts as magician, priest, doctor and artist. He plays a vital role in the life of the community who believe, for instance, that he can influence the success of hunting expeditions or ward off illness by communicating with the 'other world'.)

Of weapons, all the early cultures used harpoons, though the Dorset people, with their penchant for whale meat, made some of the finest harpoon heads, foreshafts and butts. They used bow and arrows for land hunting, and since they had no dogs it seems that they must have been masters of the art of stalking game. In some areas of northern Canada they have left behind alignments of stone cairns which appear to have been a means of frightening caribou herds into a desired lane where they could be picked off by the hunters. Possibly the women and children stood behind some of the stone heaps shouting and waving to scare the animals along the lanes. In some cases, especially around the Boothia Peninsula, they were aided by stone men, made of slabs of rock carefully piled to represent human beings. It is also possible that some of these stone giants were used as place markers to guide people going to and from the hunting grounds. They have no place in modern folklore and no history, but stand like giants, at least by Eskimo standards.

It may be that the people of the Dorset culture were the inspiration for some recent Eskimo folk tales about the Tornrit, a race of stupid people who did not know how to make proper boots but wrapped their legs in strips of skin. They are seen as a kind of bogy-men. In Greenland, however, the Tornrit seem to be identified with the Norse settlers of the eleventh century.

The slow changes in the Dorset culture are not properly understood because the sites where excavation is practicable are few and far apart. There is likely to be some sign of development in the earlier period and decline in the later, not on theoretical grounds, but for geographical reasons. The period from 1000 B.C. to A.D. 1000 witnessed at first a steady improvement in climate, and, towards the end, the first symptoms of the approaching return to colder conditions. This must have greatly influenced life for these hunters of the frozen sea, at first by making the

13

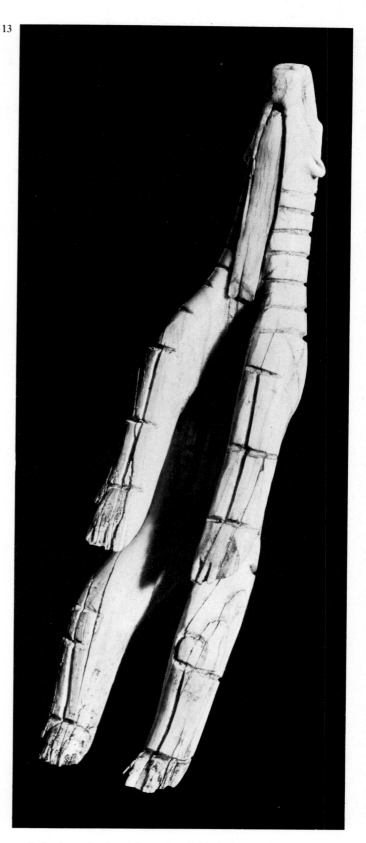

12–13 **Polar bear** (back and front views). Typical skeletal motif, with the bear shown swimming or possibly flying. Behind the sliding lid is a secret compartment in the throat containing red ochre, probably symbolising the blood of life. The legs have human characteristics which suggest that this is a shaman in disguise. Walrus ivory (3.2 × 15.7 × 3.6 cm). From the Alarnerk settlement, Igloolik area, N.W.T. Dorset culture, about A.D. 500. (National Museum of Man, Ottawa)

15

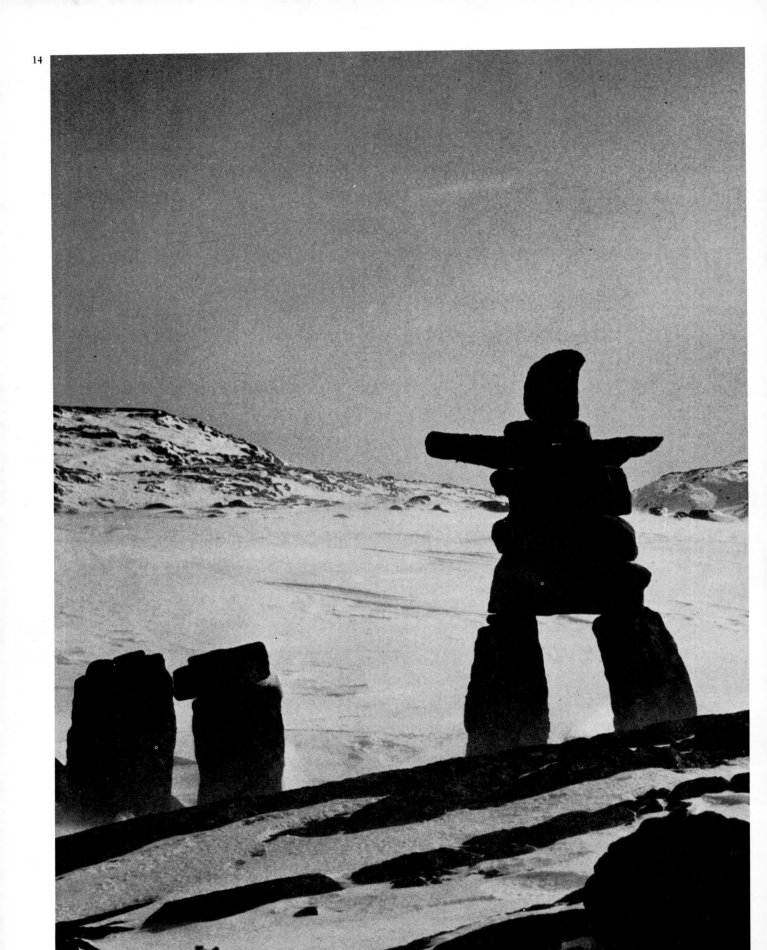

**14 Stone men** are found in northern Canada, particularly in the region of the Boothia Peninsula. Their purpose is not clear, but was probably connected with hunting the caribou. Probably Dorset culture.

**15 Stone images** by Kiakshuk. Artist's proof of stencil print. Cape Dorset, N.W.T., mid 20th century. (Gimpel Collection)

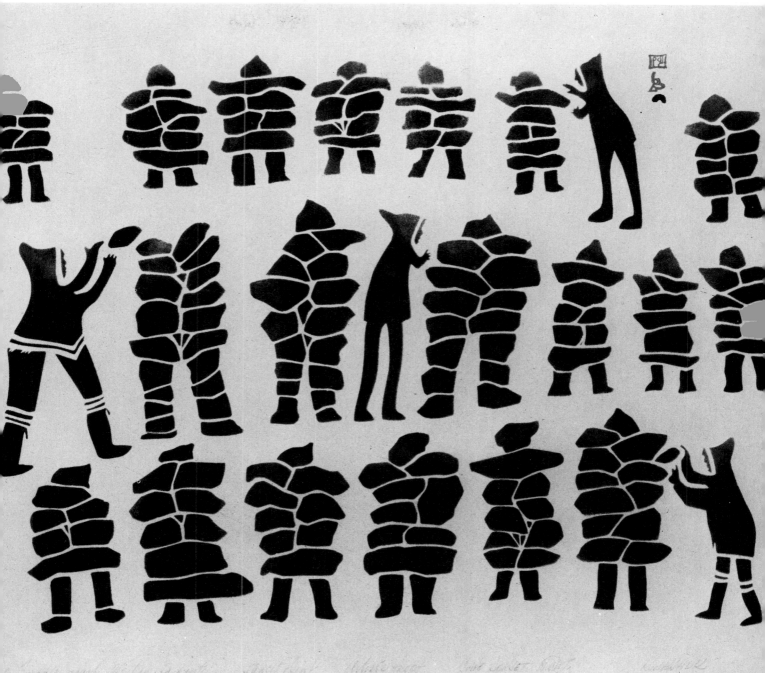

arctic more open to whales, and later by restricting their entry. There is no doubt that whale hunting was a mainstay of the Dorset period, though in the summer months when the inland areas of moss were free there was much organised caribou hunting. Something of that way of life survived among the peoples to the west of Hudson Bay until modern times. However, we must constantly remember that the Dorset people, without dogs, were likely to have

lived in very small settlements because of the limitation on travel. The hunters had a comparatively limited area in which to gain a living for the people, and so there must have been a tendency to live in small villages without very much contact with strangers. The period when it was possible for larger groups to operate together was the summer when the whale hunts would make co-operation profitable, and the use of the skin boats, the umiaks, which could

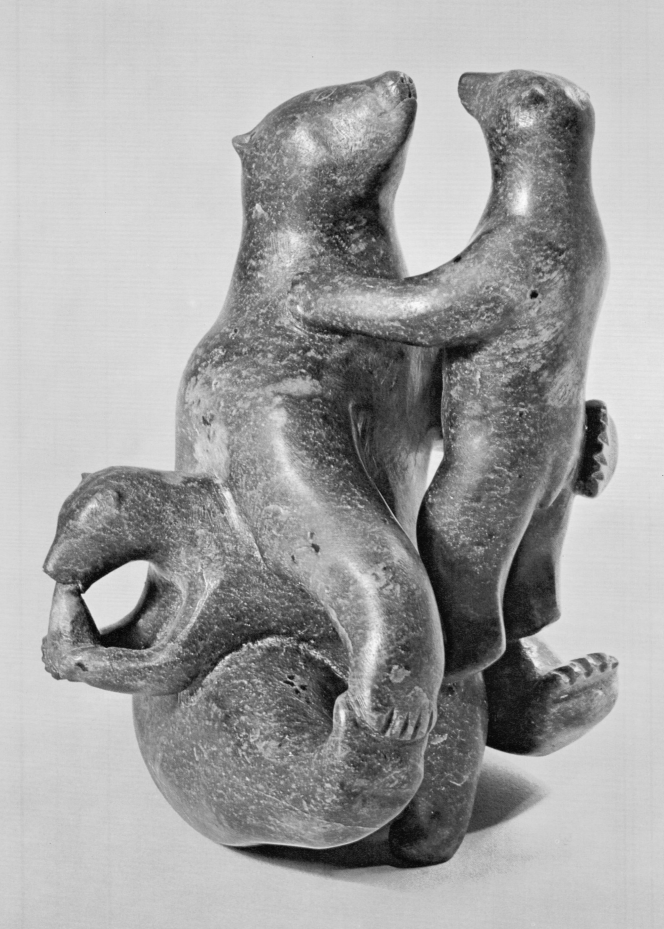

carry ten or a dozen people, made contact by coastal travel feasible.

It seems likely that some of the Dorset people of the northern Canadian area developed the ice hut, the igloo, for winter shelter. It may have developed from snow blocks piled around skin tents. In the igloo, temperatures often rose to the heat of a European summer, though the atmosphere was smoky owing to the stone bowls in which blubber was kept burning through moss wicks. People went naked indoors, and the Dorset culture figurines only rarely show traces of clothing. There are some very few ivories showing ithyphallic males, but we could not describe the Dorset people as practising any erotic art. Like the historic Eskimos, they probably lived a natural sex life which needed no ceremonial stimulus.

The spread of the Dorset culture from the Bering Sea as far as Greenland covered a couple of centuries, but we should not think in terms of a determined drive to the east. The process was probably limited to the arrival of small groups of one or two families, who settled, hunted, and occasionally travelled. The short journeys did not imply a continuous periodic migration, but visits and return to home. The carrying of culture did not mean an advance by warlike bands imposing new ideas on the aboriginal people, but rather of visits and exchange of ideas. It is quite feasible that the spread of culture was simply a matter of the spread of new fashions which one village learned from another and passed on in turn to the other known neighbours. In historic times, a man who had travelled to many different settlements was known as a great traveller. It was usual to know of only two or three other groups of Eskimos; and it is probable that travel was equally limited in Dorset times.

The archaeologist has some difficulty in excavating the sites of Dorset culture. They are all coastal, and are all on slight rises in the ground where the vista allowed a look-out to be kept for game either on land or sea. All are in the region of permafrost which, although a great preservative, presents problems for the excavator. Only in the height of summer can a few inches of soil be removed, and then during the next afternoon the sun may soften another inch or so, and for an hour or perhaps two another tiny layer from an ancient midden is exposed. The work is controlled scientifically much more easily under these conditions, but it is painfully slow. At some sites there is steady erosion by the sea, and a dig is something in the nature of rescue archaeology. However, points of excavation are few, and it is abundantly clear that a great deal more has to be done before we can truly evaluate the standing of the Dorset culture of the arctic.

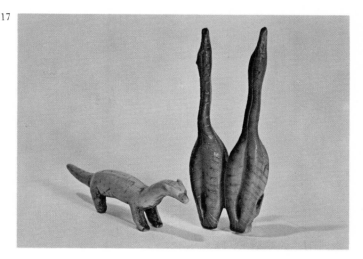

17

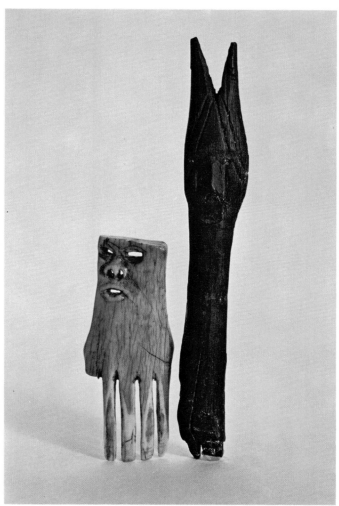

18

16 **Bear family** by Pauta. Green stone ($18 \times 14 \times 11.5$ cm). Cape Dorset, N.W.T., 1956–1957. (Collection: Mr and Mrs John K.B. Robertson, Ottawa)

17 **Ivory weasel**, probably used as a charm ($1.7 \times 5.7 \times 1$ cm). From Pingerluk, N.W.T.; **Pair of ivory swans**, probably gambling counters ($1 \times 6.1 \times 2.3$ cm). From Mansel Island, N.W.T. Both Dorset culture. (National Museum of Man, Ottawa)

18 **Ivory comb with face** ($6.3 \times 2.5 \times 0.7$ cm). From Maxwell Bay, N.W.T.; **Wooden spirit being** ($11.7 \times 1.7 \times 0.9$ cm). From Button Point site, Bylot Island, N.W.T. Both Dorset culture. (National Museum of Man, Ottawa)

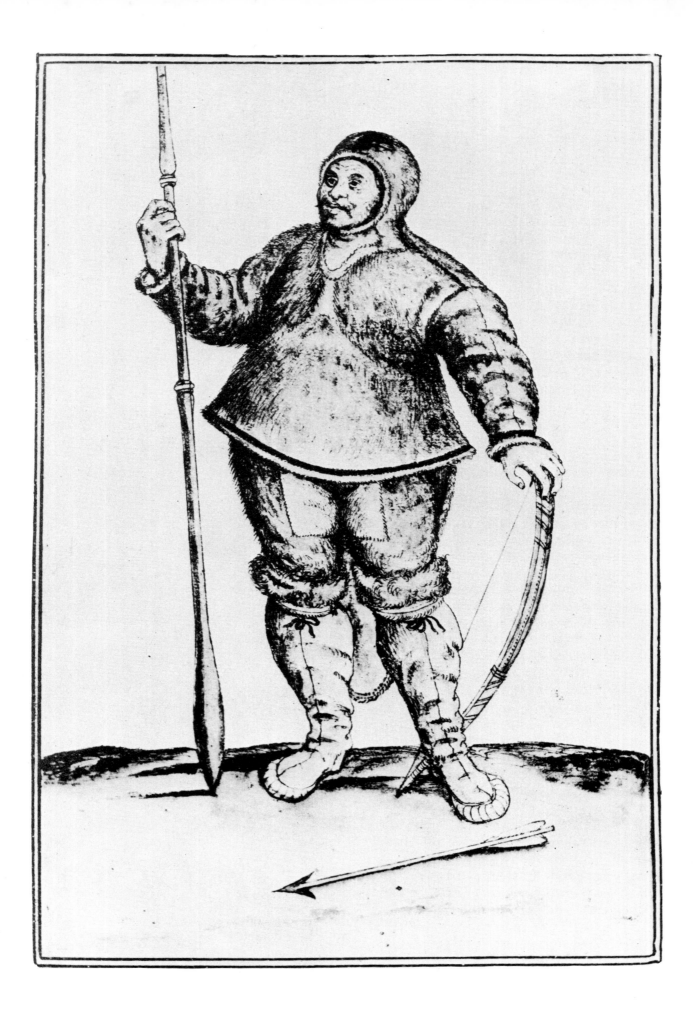

# The Northlanders

When Erik the Red quarrelled with his neighbours and would not abide by the laws of Iceland he was exiled. With several boatloads of friends and foreigners he set out for Greenland. Some were wrecked on the east coast, but Erik landed on the west coast. He found a fine country with a fiord containing green meadows enough to feed his cattle. There were no people around, no sign of the fur-clad natives, but on the beach he noted some stone arrowheads. Those arrowheads had been left by people of the Dorset culture who, with the return of a warm climatic spell, had moved northwards to continue their life hunting the creatures along the edges of the ice.

Archaeologists have found that just about this time, A.D. 1000, the people of northern Greenland, at Thule, underwent a change in their culture. Eskimos coming from the west had brought new things which their distant cousins in Alaska had discovered a couple of centuries earlier. The progress of the new ideas was still very slow because of the impossibility of moving quickly from one area to another except in summer, and possibly because of the hostility of the older population of Dorset culture people. The newcomers brought the dog, the dog-sledge, and the single-seater kayak. They relied more on seal and walrus for their food than on whale, though inland they still hunted mammals in summer, but with less emphasis on the caribou. However, the warm climate was coming to an end, and the caribou were not so frequent along the shores of the Arctic Ocean, and as they moved inland they came less within the range of the sea hunters. But the hardy musk ox was available throughout the area. The change in the balance of nature made it necessary to adapt a little, and it appears that the Dorset people had not changed their ways sufficiently, and eventually had to adopt the ideas of the bringers of the new Thule culture.

We do not know whether the people of the Thule and Dorset cultures were conscious of being one race. The difference between their ways of life was considerable. On the whole the modern Eskimo view is that their folk tales reflect the past rather well. If that is so, the newcomers viewed the older people as incompetent and uncivilised. Certainly there was a radical change in art styles. The deep grooves cut in surfaces no longer appear, the degree of stylisation is less, and the curved surfaces are more gentle. Moreover, the quantity of works of art seems to decrease. We gain the impression that these people, with the means of life extended by the use of sledge and dog, were facing a hard struggle with the climate and were so busy that few works of art were made in leisure time, now so scant that all effort was directed to the hunt.

As the climate became worse, the northern peoples of Baffin Island and Greenland found their way southward, and came into contact with the Norsemen in the regions around the southern fiords. Surviving legends tell of bitter conflict, of Eskimo resentment at barbarous raids by the strangers and of revenge killings. The cultural exchange seems to have been minimal. There were a few carvings made of people in strange clothes, including some with hats in fourteenth-century European fashion, but they are not numerous.

There was no chance of the two races ever understanding one another. The Europeans, suffering from the effects of the climatic failure, were clinging desperately to their own culture: church going, clothing of a Norse type, and plank-built boats. And they were still able to keep up a little contact through an annual trading vessel from Denmark. All in all they despised the little savages who lived like trolls. The Thule people had little to learn from the Norsemen. Perhaps some ideas about the construction of roofs in huts came to them. Their skin kayaks and umiaks were more adaptable than the wooden boats of the big men, and their paddles were more efficient than oars. Skin clothing was as good as anything the others had. In hunting the Eskimos were more efficient. And they were ready to repay the Norsemen for their cruelty. In the end there was fierce fighting, but the final victory was not glorious. The Norse settlers were undernourished, dwarfed and crippled with rickets. They could have made little resistance. As the last messengers from the Greenland settlements came to Rome, Christopher Columbus was setting out for the Indies. The northern sea

---

**19 Drawing of an Eskimo** by the Elizabethan voyager, John White.

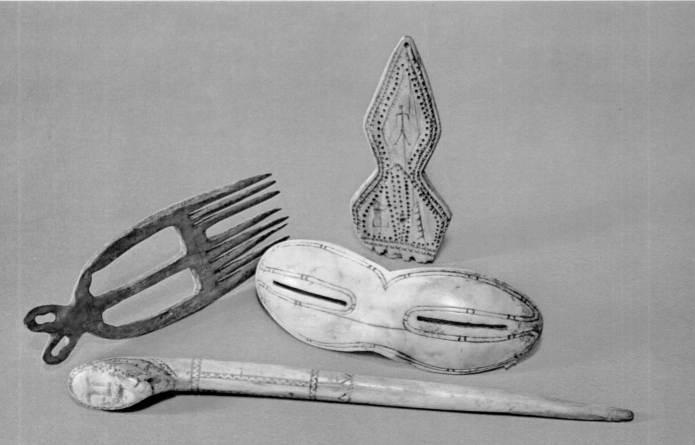

**20 Hunters** by Parr. Stone cut (61 × 91.5 cm). Cape Dorset, N.W.T., 1969.

**21 Group of ivory objects: Marrow pick** (1.9 × 20.4 × 2.7 cm). From south side of Strathcona Sound, N.W.T.; **Comb** (12 × 4.55 × 0.55 cm). From the Sleeper Islands, Hudson Bay; **Engraved comb bridge** (10.4 × 4.3 × 0.6 cm). From Igloolik, N.W.T.; **Snow goggles** (4 × 11.5 × 1.7 cm). From Maxwell Bay, N.W.T. All Thule culture. (National Museum of Man, Ottawa)

**22 Aleut hunting hat** of painted wood with incised ivory, beads and sea-lion whiskers. Not only did the cap shield the eyes from dazzle, it also afforded magic protection. From Alaska, about 1850. (Museum of the American Indian, New York)

**23 Ivory two-man pendant** (4.6 × 2.35 × 1.05 cm); **Ivory ornament**, possibly a wound plug (5.6 × 1.35 × 0.9 cm). From Maxwell Bay, N.W.T.; **Ivory ornament** (4.65 × 1.9 × 0.3 cm). From Belcher Islands, Hudson Bay. All Thule culture. (National Museum of Man, Ottawa)

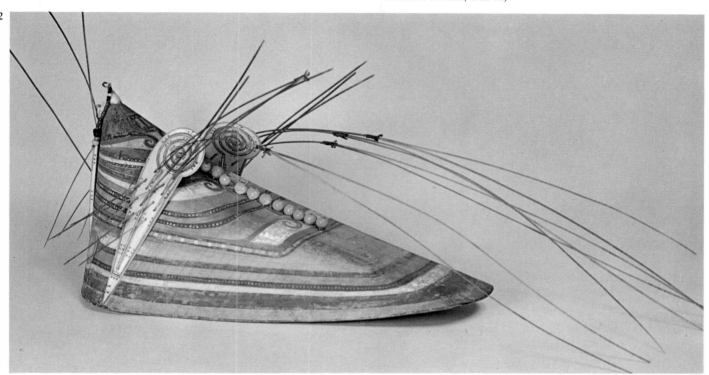

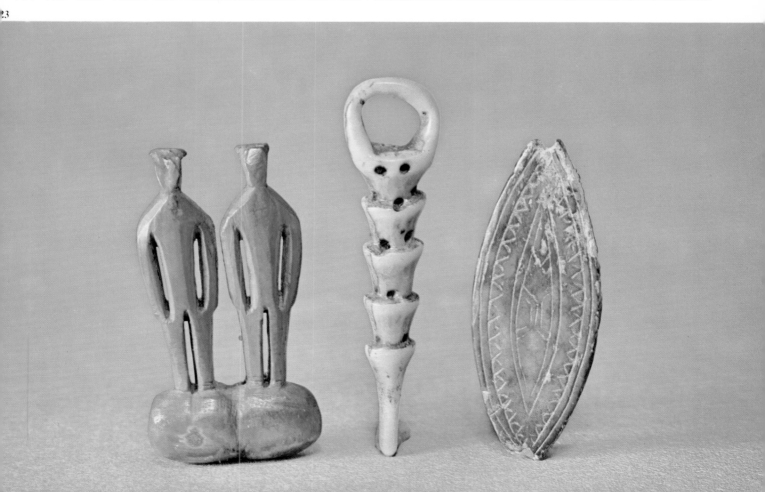

hunters were not to enjoy peace for long.

It was at about this period that the Eskimos achieved their most southern settlements when they established themselves in parts of northern Newfoundland and on the Labrador coast. These people, like the southern Alaskans, had access to growing trees, but they did not stay for very long in the new environment and moved north again among the barren rocks and icy hunting grounds they knew so well.

One of the serious effects of the falling in world temperatures in the thirteenth century was that whales in the arctic seas became rare. The open summer seas in which the great animals were hunted by large groups of people in umiaks were more and more restricted. The Thule people were forced to rely more on seal and walrus in the sea and caribou and fish inland. This meant that the grouping of families possible where whales were plentiful was no longer useful. The developed Thule culture is more and more found in small sites around a centre where the animals could be hunted successfully. If there were too many people the food supply for them would be insufficient, so two or three families would constitute a unit. Contacts with other people were rare, though inbreeding did not become much of a problem. The rare social visits were occasions of sexual courtesy which did much for the health of the families. However, the isolation of the small family units meant that everybody was fully occupied in obtaining a living and in making practical objects. They did not have any time for art for art's sake, but faced so many dangers and difficulties that they charmed many objects of everyday use by carving and incising on them heads of animals and pictures of successful hunts. There was a steady output of carved gambling counters, and a few charms were made to attract food animals, or to point out to the spirit world that the people needed help.

The problems of the polar north were reflected, no doubt, in other areas. But in Alaska the pattern of life was richer. The Pacific, which was open for longer periods, supplied whale, and hunting in the umiak was an important feature of life. The natives of the Alaskan mainland coasts varied a great deal among themselves, mostly for geographical and ecological reasons. They were all true Eskimos, though as usual they lived in widely separated groups. On the southern Alaskan coast they had fairly close contact with groups of Tlingit Indians, and adopted some cultural ideas, masks, and house types from them, although the relationships were hardly friendly. The country was well wooded, and the Eskimos built semi-subterranean family houses which served as permanent headquarters, though they used skin tents when away hunting in the summer. However, their main living came from the sea.

Northwards, towards the delta of the Yukon river, timber became more scarce, and the small Eskimo communities lived in any area where there was good access to the sea and where sea hunting was good. They also used fixed-home houses even if a village was only of five to ten households. These were often built of slabs of stone and masses of earth, with a window over the low tunnel-like entrance. The people lived mainly by sea hunting, but occasionally they ascended the rivers to hunt caribou and deer. However, in this inland region they felt ill at ease and were often involved in bloody conflict with bands of Kutchin Indian hunters. As far as possible they avoided contact and preferred to work from their own coastal areas. Such a way of life was hardly comparable with that of the other Eskimo regions. This cultural disparity is clear throughout the archaeological record. At every stage, the house ruins of western Alaska were larger and better appointed than those of other communities.

Around the rocky north west coast of Alaska to the low clay soils and mudflats of Point Barrow there were ice hunters who conformed more to the usual pattern of Eskimo life. In the Bering Strait area there were Eskimo hunting communities settled on the island of St. Lawrence, and on the Diomede Islands. They were all sea hunters who spent the shorter winter seasons in ice hunting over the frozen sea. From early times there was an ancient trade route across the Bering Strait between peoples from Siberia and Indians from southern and central Alaska.

In the Bering Sea area the Aleut people were a special group of arctic fisher folk. They spoke a language grammatically close to the Inuit of the Eskimo, but with a very different vocabulary. Their homes on the Aleutian Islands and the western tip of the Alaska peninsula determined their close relationship to the sea. They were the most southerly relatives of the Eskimos, living in a region far below the Arctic Circle, where the Pacific Ocean is rarely frozen. They developed larger and more efficient skin boats, including a multiple-seater kayak, wore fine waterproof skin clothing for fishing expeditions and utilised timber and bark. Their art was very individual, but many motifs seemed to echo the swirling curves of the Old Bering Sea culture, though it is unlikely that there was any direct contact across such a great expanse of time. One of their more famous art products was the bark eye-shade, a pyramidal hat of birch bark adorned with painted patterns and seal whiskers.

Although, in a sense, each Eskimo group had an individual culture, in the early historical period they

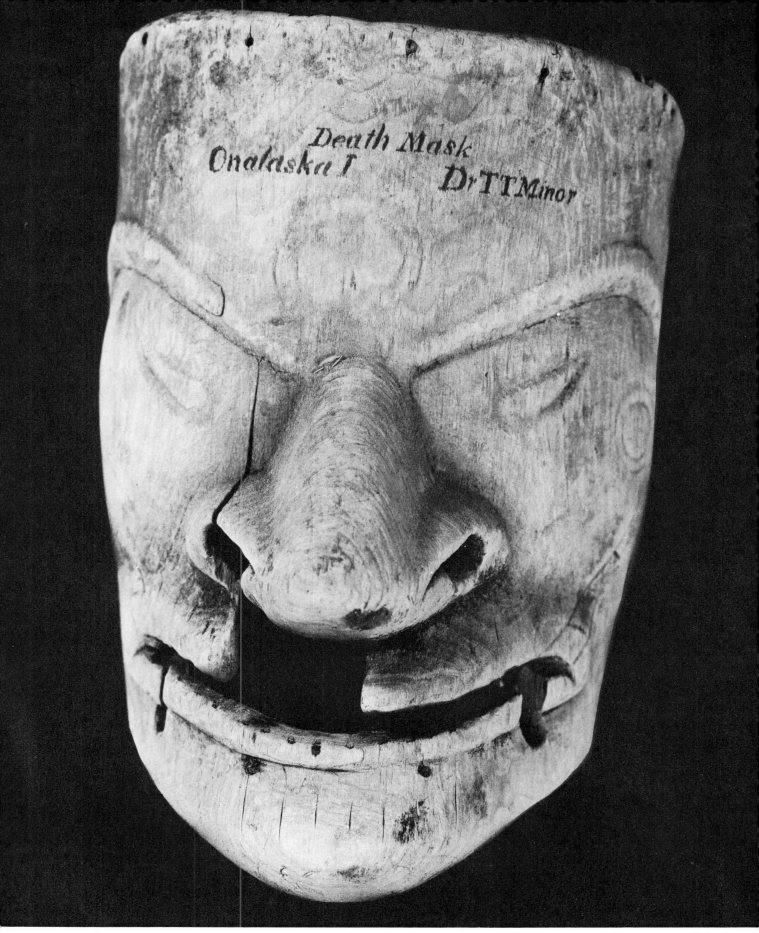

**24 Carved wooden death mask.** From Unalaska Island. Aleut, before 1869. (Smithsonian Institution, Museum of Natural History, Washington D.C.)

25

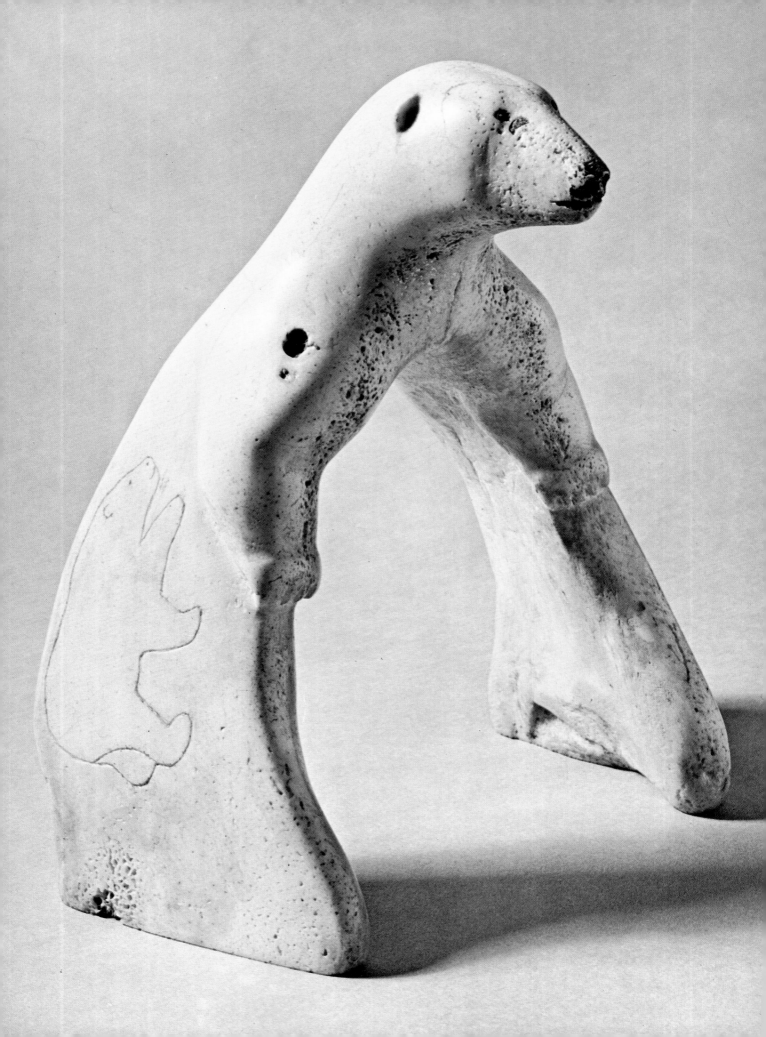

26

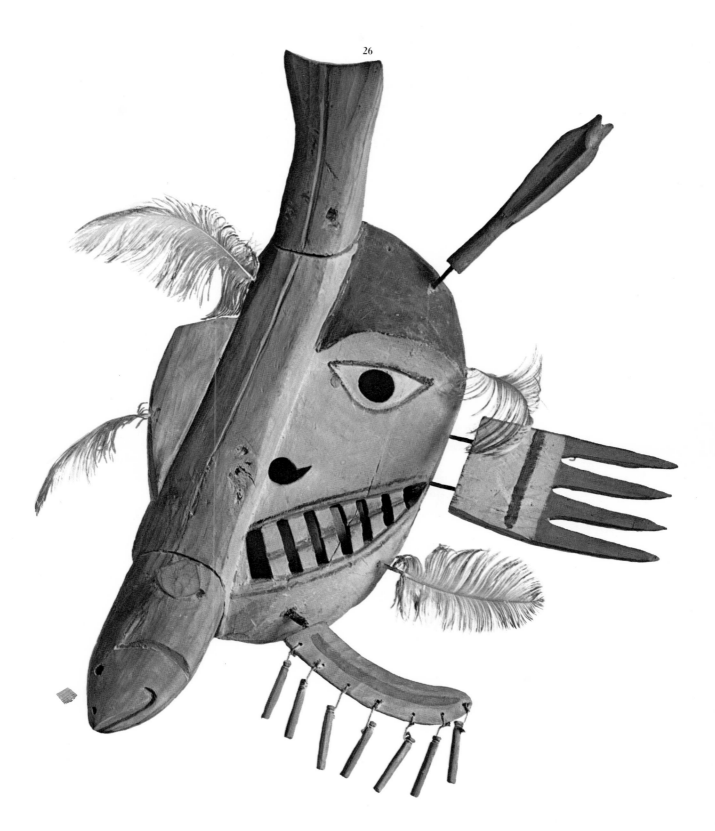

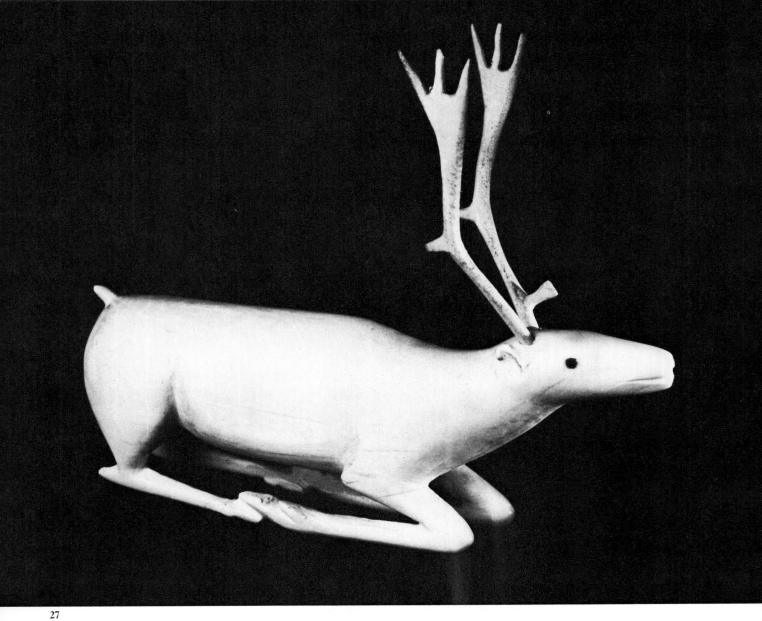

27

had a common basis in the Thule culture. There were, however, two unusual variants which are of importance. At the mouth of the Coppermine River in north western Canada the Eskimos produced tools of copper. They were a rare example of people using metal with a Stone Age technique. As far as the Eskimos were concerned the green-stained nodules of natural copper were stones, but with the special property of malleability. It was possible to hack at one of the copper boulders until a piece could be wrenched off, and the soft stone did not break when hammered, but spread out as if it were some kind of paste. With hammering, smoothing with stones and filing on coarser stones, the copper made very adequate harpoon points, knives and fishhooks. The metal was a convenient material for use, but was not so remarkable that it was used in any other region. The few visitors who came do not seem to have returned for trade. An Eskimo aesthetic based on practical shapes for use determined that the copper implements had similar forms to those made from

slate. Indeed, in actual practice copper was no more useful than slate. Neither did the metal have much use in producing works of art except that a few ivory figurines were fitted with copper studs in lips and cheeks where the local women would have worn stone ones. It was the malleability and toughness which made the local copper an attractive material. No one has any record of the poisonous qualities of its oxides. The metal was never heat treated because the Eskimos had no means of creating a high temperature. The flame from the usual blubber lamp was hot enough to boil water but nothing much more. In the few places in Alaska where a coarse pottery was made, wood fires were available, but among the Copper Eskimos, burning wood would have been a wasteful use of material brought by the sea for use in making tools and weapons.

The other aberrant group were the very old-fashioned Caribou Eskimos who lived in the barren lands north west of Hudson Bay. They had apparently deliberately decided to reduce dependence

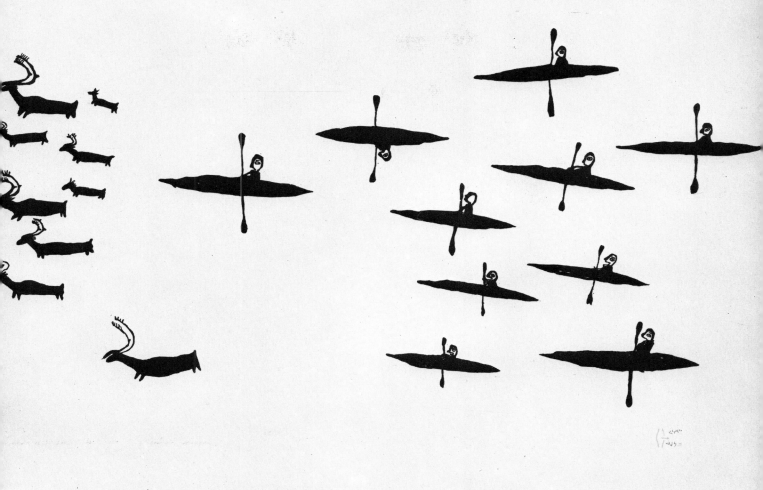

28

on seal hunting and concentrated on following the caribou herds as they passed on their way to summer or winter pastures. There was land hunting in which the animals were driven by all the free members of the group towards the hunters. As in Dorset times, piles of stones were erected which the animals mistook for hunters. These served to channel the path of the animals in the right direction. However, the hunts were never exterminating attacks; always sufficient animals were left to escape to keep the food supplies ready for later years. At river crossings much used by the caribou, the Eskimos hunted them with spear thrower and lance propelled from a kayak. On occasion the Caribou Eskimos made snow huts, but usually they lived in their skin tents, reinforced by snow blocks in winter. They were constantly busy with their hunting life, but produced a number of small carvings both useful and magical. In some ways they were akin to the Dorset culture, but in all important aspects they were Thule culture people with the dog-sledge and kayak as their means of

transport. Their very small bands of a few families of caribou hunters must have resembled in many ways the tundra hunters of the last Ice Age in Europe.

The most remarkable group of all were the inhabitants of north west Greenland. They were typical people of the Thule culture, and had adapted to the heavy ice of the far north as well as the grim darkness of the months of winter night. It appears that they had been part of a general eastward movement of Eskimo groups, and it may well be that they also included some southern Greenlanders who had moved northwards in the period of optimum climate in late Dorset times. They were discovered by Eskimos from the Pond Inlet region of Baffin Island as late as the 1860s. By this time, whalers were operating in the arctic seas and the Pond Inlet people

27 **Kneeling caribou** by Piluardjuk. Ivory ($12 \times 14 \times 2.5$ cm). Repulse Bay, N.W.T., 1960–1962. (Collection: Mr and Mrs D. F. Wright, Ottawa)
28 **Kayaks and caribou** by Angosaglo and Ikseegah. Print. Baker Lake, N.W.T., 1972.

29

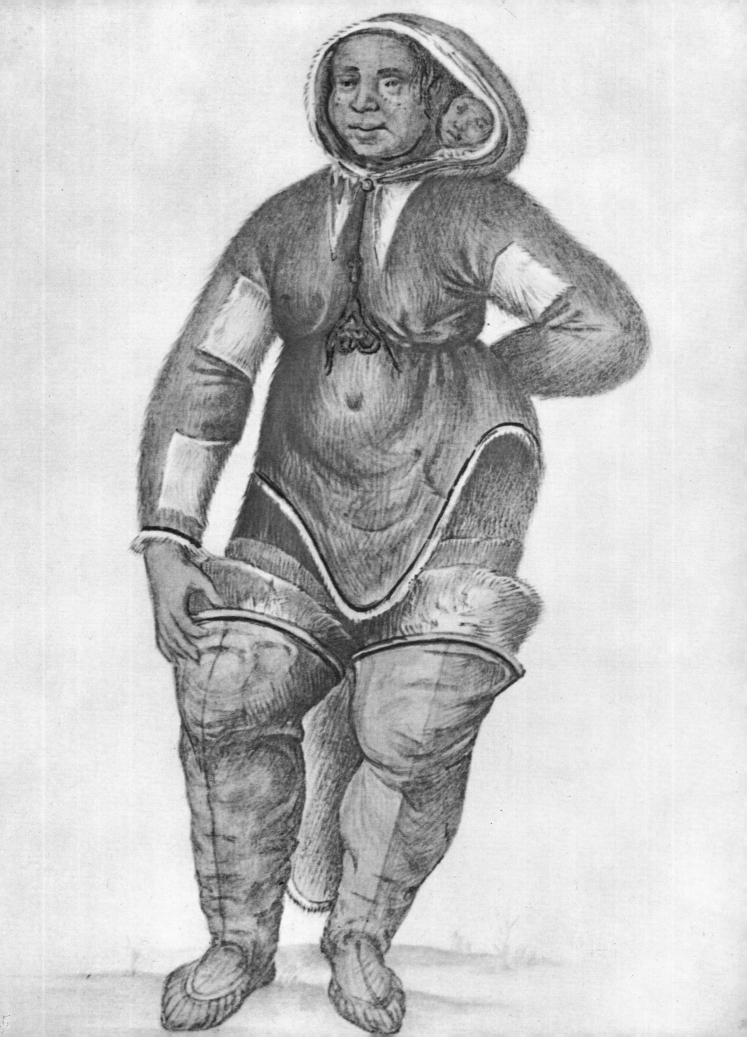

**29 Eskimo woman in furs with a baby on her back.** Watercolour by the Elizabethan voyager, John White. Note the facial tattoo and three layers of leg covering.

**30 Eskimo recollection.** Ochre and grey stone ($2 \times 12 \times 12$ cm). Port Harrison, Quebec, 1951. (Collection: Ian Graham Lindsay, Ottawa)

**31 Whale-bear-bird monster.** Green stone. From the Canadian arctic, mid 20th century. (Gimpel Collection)

30

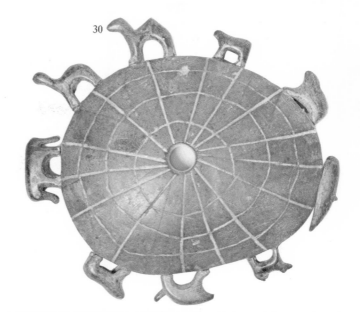

31

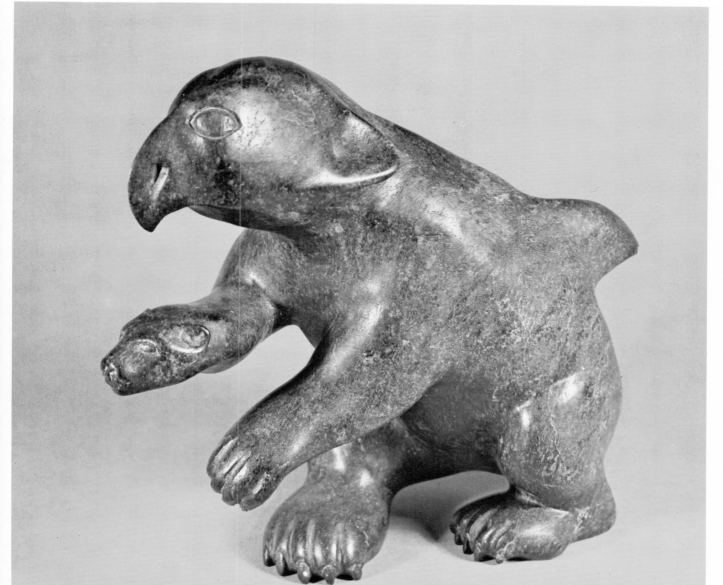

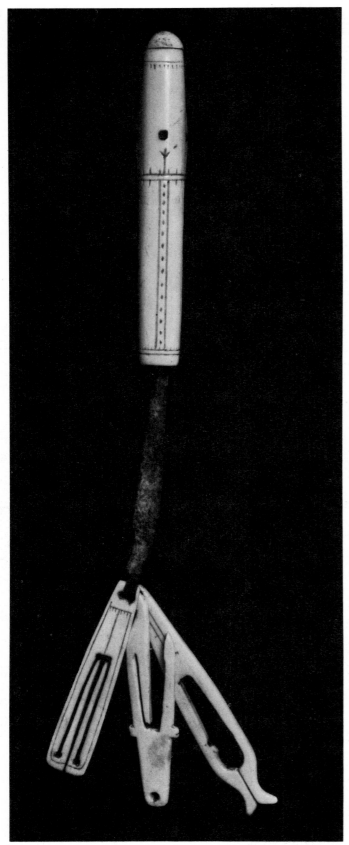

**32 Ivory needlecase.** Western Eskimo, 19th century. (Museum of
Mankind, London)

**33 Wooden mask** representing Negakfok the cold weather spirit, the
Eskimo equivalent of Jack Frost. (92 cm high). From the
Kuskokwim river area, Alaska. (Museum of the American Indian,
New York)

heard from them of other Eskimos far away in the
north. They determined to visit them, and made the
long journey from the Canadian arctic across Devon
Island and Ellesmere Island to Smith Sound. In just
such a way their ancestors may have occasionally
moved, either to find better hunting grounds or to
meet other human beings in the great loneliness of
the ice. This journey of over seven hundred miles was
achieved by a compact group of a few families who
simply travelled until they achieved their objective.
Hunting was good all the way and they knew the
general direction in which to go, through the stories
of the whalers.

On reaching the Polar Eskimos of Smith Sound,
they found them backward indeed. To the Polar
people, the Pond Inlet Eskimos must have seemed
wonderful, for they brought long forgotten arts with
them. It seems almost incredible that the Polar
people had no knowledge of the multi-pronged
leister for fishing, nor of the kayak, nor of hunting
caribou with bow and arrow, nor how to hunt on the
open sea when the ice melted. Archaeologists have
shown that long ago their ancestors could build
kayaks, but apparently under polar conditions the
short period of open water made the labour of kayak
building not worthwhile. In any case, during the
climatic regression of the thirteenth century it is
possible that the ice never melted at all in north
Greenland.

It is quite clear from archaeology that there had
been many movements of Eskimo groups around
Greenland, and no simple theory of migration can
account for the distribution of culture sites. However,
this last cultural migration and influence of culture
contact is recorded and gives a good example of the
kind of travel which had occasionally occurred
throughout history.

At the eastern end of the continent the people of
Greenland had not only moved southwards, but also
took cultural ideas westwards and modified the
cultures of the people around Hudson Bay. But we
must remember that although designs appear to have
been spread in planned movements, the fact is that
actual contacts must have been rare and that there
was a good deal of local development in which
practical needs determined similar alterations of
design in tools and weapons. For instance, the whole
central area was much more devoted to caribou
hunting and fishing than other areas, and the people
were forced into seasonal migrations. Whereas the
Eskimos on the edge of the open sea were more
settled, and their culture was centred more on the
whale and the walrus. And some of the West Coast
Eskimos were so close to the groups of American
Indians that they almost merged.

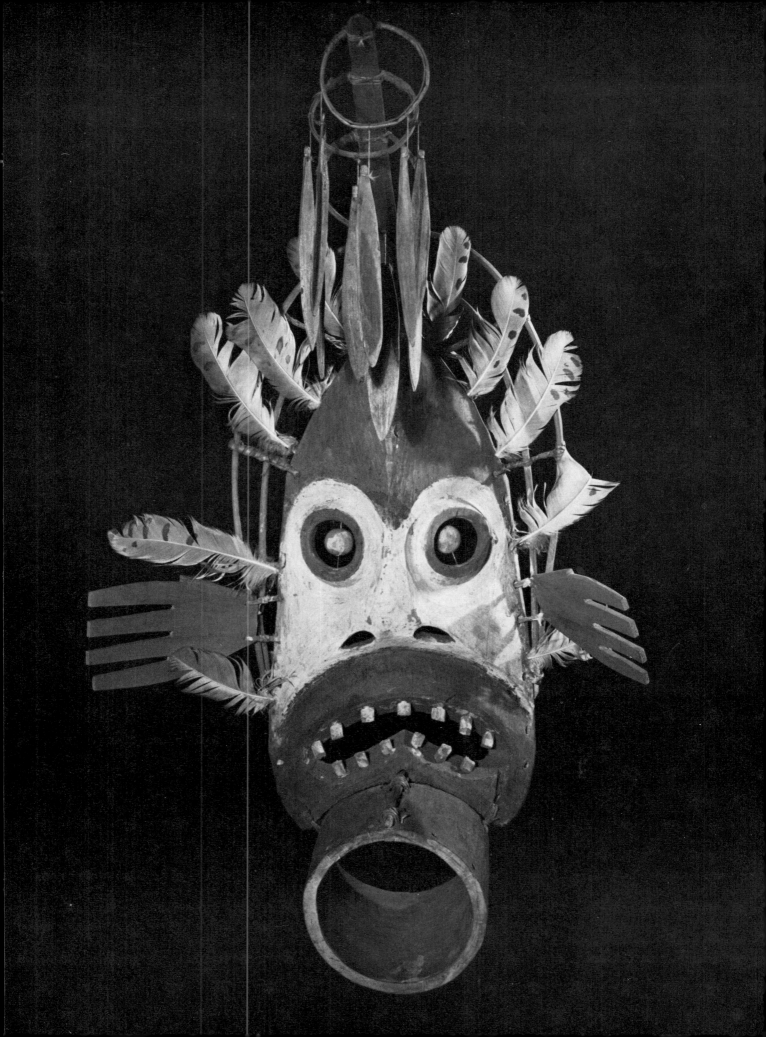

During the whole period of prehistory, the artists of the northlands had been a people of the Mesolithic hunting culture. Their finest work was the result of infinite patience, using stone tools and sometimes burnishers of polished stone. They devised many forms of scrapers and knives, and in particular a long side-bladed knife which was laid along the whole forearm so that an even pressure could be applied. They not only carved in soft driftwood and bone, but also made wonderful things from ivory. The ivory tusk of the narwhal, the great tusks of the walrus and teeth from the seal all formed marvellous material for the artist, who was probably a shaman as well. Most of the carvings were quite small, and their shapes were usually little altered from the original form of the ivory used. The shape of a tooth was easily turned into an animal head. Bones made longer figures, such as were needed when making arrow-

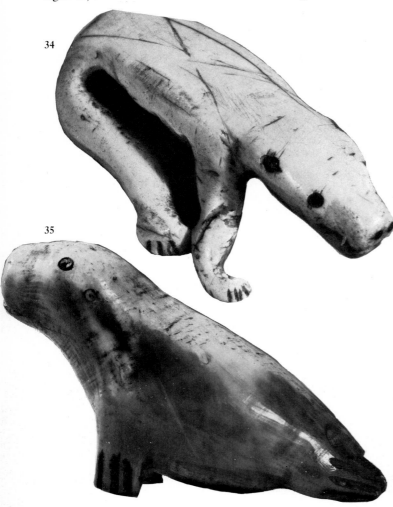

34–35 **Small ivory charms** in the shape of a polar bear and a seal, probably sympathetic magic for hunting. Probably from the Canadian arctic, 19th century. (James Hooper Collection)
36 **Ivory drum handle.** (14 cm long). Probably from the north coast of Alaska. (Museum of Mankind, London)
37 **Drum dancer** by Bernadette Iguptaq. Grey stone and bone (9.5 × 5 × 13.5 cm). Repulse Bay, N.W.T., 1963–1964. (The Twomey Collection, Government of Manitoba)

straighteners. Hard stone was sometimes polished into shape, but the form used was normally a pendant which could be used for flaking the edges of tools of flint. Soft stone was carved to make the saucers and dishes which were used as lamps and cooking stoves. Small figures of wood and ivory, and only very rarely of stone, are known, but they are comparatively infrequent. From northern Alaska some masks made of pieces of bone, carved and fitted into a wooden frame, have been found. Masks were usually tiny amulets, but full-sized wooden masks are known and also some made of the cancellar tissue of whale limb bones and skulls. These, however, derive mainly from Alaska.

All in all, if we were to consider the archaeological records without any further evidence we should be forced to think of the ice hunters of the Dorset and Thule cultures as people showing a development through time, mostly involved in making practical tools and useful artefacts, but from time to time producing objects of high artistic quality. They would be seen as a practical race of ice hunters, who had artistic ability but little time to develop their art. The mainspring of their art we would guess to be the cult of spirits concerned with success in the food quest; but the legends and folklore behind their way of life, and the living force inspiring the artists would remain unknown.

At the height of the Thule culture the Eskimos were self sufficient. They had no need of outside contact, though metal was a desirable novelty. On the whole they preferred to be apart from other humans, and most of them were so isolated that they were to all appearances the only people in the universe. Their art remained very practical, but they devoted a part of their time to making representations of people, animals and the beings of their spirit world. Every work of art had life and a spiritual meaning, and every individual might be an artist.

The groups of people living by hunting must not be so big that the game was insufficient. If a settlement grew big some people hived off to find new hunting areas. If the game failed, people strove to keep alive. But often whole settlements died quietly in the snow; they joined the spirit world which was so near. In that land of chasing mists and blue skies, of sun and stars, of strange noises on the ice and the ever dancing aurora, the inner personality of the people was unusually free to experience dreams and visions. The more sensitive people became shamans (the Eskimo word is angakoq) who would prophecy while in trance, self-induced by drumming on the big seal-membrane drums. Other people would discover that they were helped by protective spirits and would call on them in any trouble.

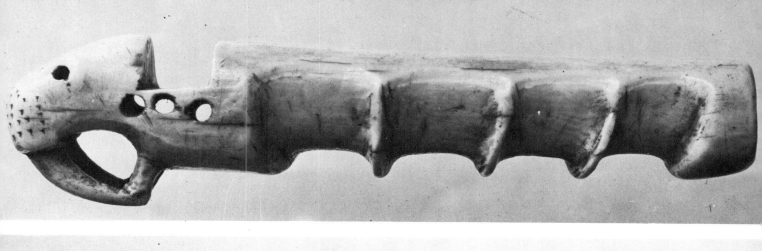

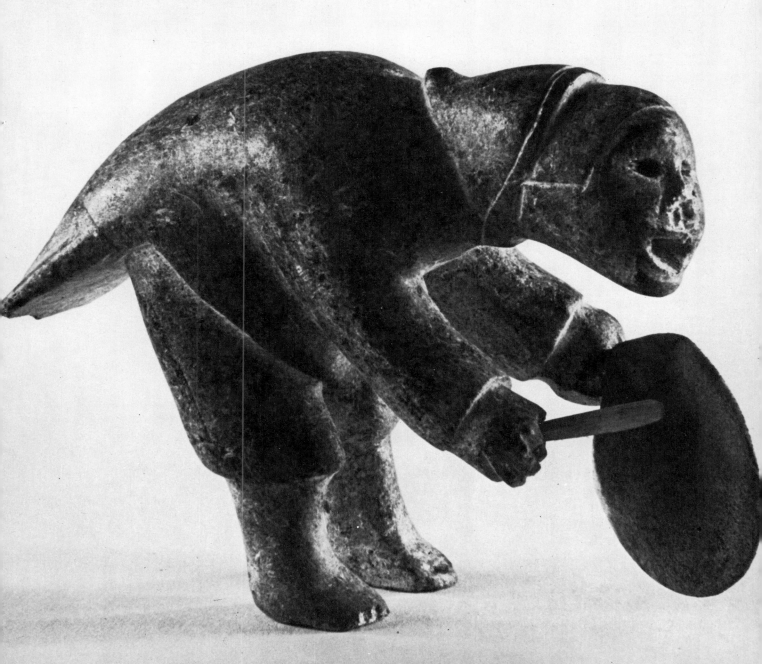

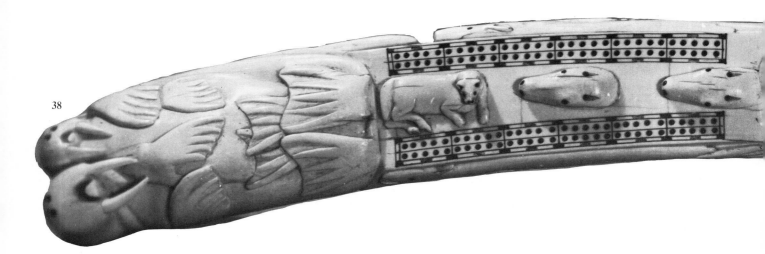

**38 Ivory cribbage board** decorated with sea creatures said to have originated from the fingers of Sedna, the great mother under the sea. From Alaska, 19th century. (Cincinnati Art Museum. Gift of Samuel Ach)

38

Eskimo religion was a complex of beliefs which were accepted all over the arctic. Each group might have some individual beliefs, but as a whole the people had similar ideas about the supernatural world which was always so close to them. There were no fixed ceremonials, no sacred days, but many hearts rejoiced when the sun reappeared after the long arctic winter night. On the days before migration to summer or winter hunting areas there were dances and, of course, much questioning of the spirits about the nature of the coming season. Under the sea was a great mother figure, usually called Sedna, whose fingers and toes became the sea creatures. She was always creating life, and was always aware of what happened to her creatures. The animals were not just things to be destroyed and eaten, but living beings who showed intelligence. Their souls were important and had to be placated. A captured seal was addressed thankfully that it had given its life for the people, and a piece of skin was specially cut and left behind as a symbol of the hope for a renewal of living seals. Birds, caribou, musk oxen, foxes, hares, freshwater char, and great whales were all part of the living world. The hunter by observation achieved a certain degree of identification with his quarry, and this is reflected in the art he produced to bring them to his net. He himself was part of this living world and so he never violated it, never killed for pleasure, and never took life without thought and prayer for new life. So near to the basic subsistence of the wild he had a respect for all living things: hence a certain gentleness of character which he displayed in his everyday living.

It is the belief in the unity of all living things

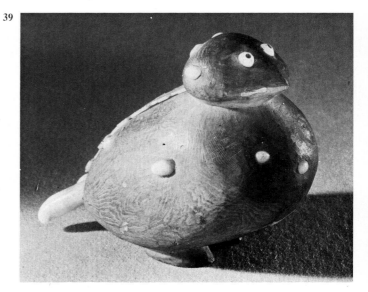

39

which gives so strong a human appeal to Eskimo art. The images are not simply forms or representations; they are not the sole product of the conscious fraction of human personality, but the expression of an inner world which the Eskimo has experienced through the ages. The shaman is believed to be able to visit the land of souls, to find the great Mother under the sea, and to discuss with the spirits of seals, walruses and whales the ways of life. It is the universality of the ideas within Eskimo art which makes it acceptable to folk of other cultures. We find similar themes about man and nature preserved in ancient fairy tales and legends which were once stories of the gods. We remember that the Northern gods were once shape changers and knew the thoughts of the birds and beasts.

36

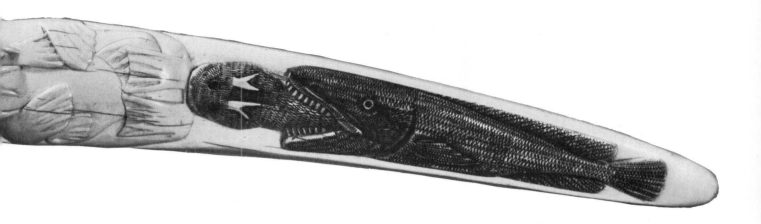

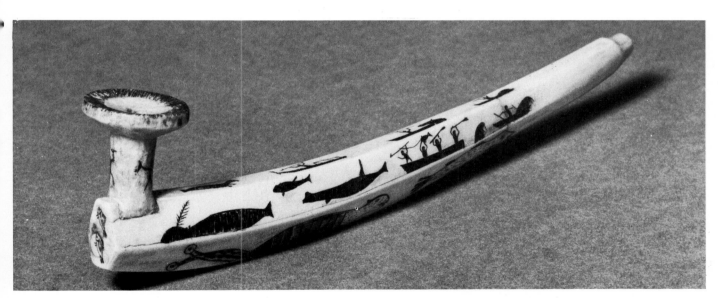

The first work of Eskimo art known to have been treasured in Europe came from an excavation of a house destroyed by the fire of 1413 in Bergen. The little ivory walrus came from a layer well below the fire zone and is thought to have belonged to the twelfth or thirteenth century. Brought by a Norseman from the land of the Skraelings, it was once a link between hunter and hunted in an Eskimo tent.

The last phase of the Thule culture was to be observed by strangers from other lands, by men who scratched pictures on whales' teeth as a leisure activity, and who often enough died in the arctic because they could not live like the people whom they called Eskimos. Their evidence is to be found in many books of travel and exploration. Among them were artists who depicted the strange world of ice and snow where people clad in furs lived in skin tents and marvellous domed houses of snow blocks. From the beginning of contact the Eskimos became famous, and romantic images of them filled the European mind.

It is quite obvious to us now that those Eskimos of the travellers' tales were the people of the Thule culture and the ancestors of the Eskimos of today. Nothing in the archaeological record shows any major difference. The physical remains of the people are indistinguishable, though we must remember that all the peoples of the north are physically much the same through all the changes of culture. What the modern Eskimos adopted from the previous Thule people is not certain. It may be that the snow-built igloo of the Canadian arctic is a development of a

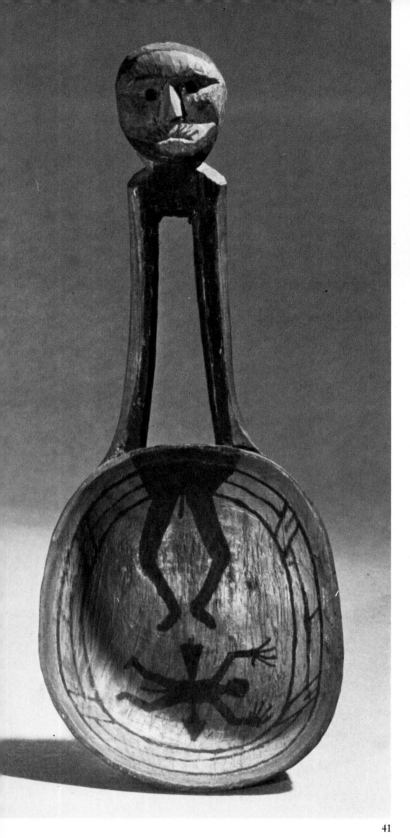

Thule construction. Certainly the use of the umiak type of boat persisted, together with snow goggles, snow knives and harpoon types, though the decoration on them is in a new style. But all these articles are necessary to life by the arctic seas.

With the arrival of the explorers, archaeology suddenly turned into history. It was an interesting time because the arctic was changing once more. The worst of the cold period, which had destroyed the Greenland settlements around Eiriksfiord, was slowly receding. The summer ice covered less and less sea each year. In the sixteenth century, Frobisher went to the arctic and reached Ungava Bay, then the limit of navigation, though now it is by no means the end of open sea, not for a thousand miles. Frobisher had some unpleasant experiences with the Eskimos, who tended to ambush the visitors and shoot bone-pointed arrows into them. No doubt they thought these sailors were a party of returning Norsemen whom they looked upon as bloodthirsty barbarians. Yet there was peace at times long enough for the artist John White to make records of Eskimos as persons as well as an attacking party threatening a boat's crew.

Everything about the Eskimos depicted by John White shows them to have been indistinguishable from modern Eskimos – or at least from their grandparents. The costumes were similar, the weapons just the same. Similarly the elegant little skin kayaks were noted and drawn. These Eskimos were not land lubbers, but quickwitted and active hunters who knew their country by sea even better than by land. They had skin tents, and wintered in snow-domed igloos. People wore tattoos, especially women, and their indoor dress was scanty. They were a well-greased people who smelt strongly of smoked fish, yet they were attractive to the visitors because of their personal qualities. There might have been fighting, but there was also trading and laughter. Importantly we note that under the terrible conditions

41

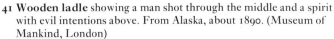

41 **Wooden ladle** showing a man shot through the middle and a spirit with evil intentions above. From Alaska, about 1890. (Museum of Mankind, London)
42 **Barbed spear point,** engraved with sea hunters in umiaks. Ivory. From the Canadian arctic. Acquired in 1933. (Horniman Museum, London)
43 **Europeans as seen by the Eskimos.** Wood (tallest 10 cm high). Found at Upernavik and Angmagssalik, Greenland. 14th–19th century. (Danish National Museum, Copenhagen)

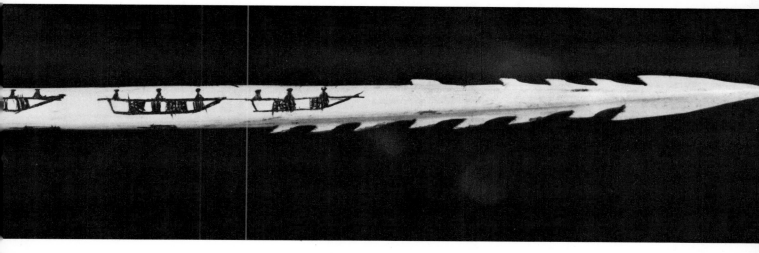

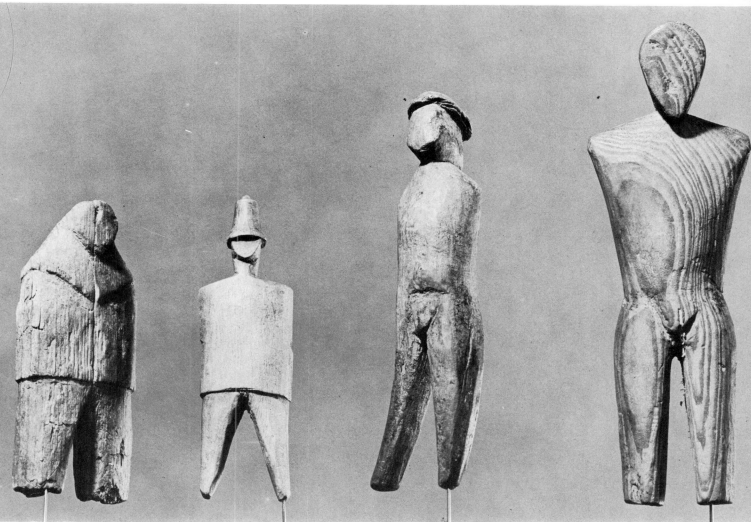

43

of the arctic coasts the white men had little advantage
over the Eskimos, and so it was possible for the two
groups to respect each other. Neither were the
numbers of people involved ever very large. Under
the optimum conditions where Eskimo communities
were able to unite in whale hunts there were rarely as
many as two hundred people involved. Usually the
isolated little groups of twenty or thirty people

presented but a small threat to any ship's crew
sojourning among them. Neither did most sailors
present any threat to the Eskimos. Sometimes
goods were stolen, but more often there was trade
for metal nails, and strange foods in return for furs.
Most families welcomed sailors as temporary sexual
companions, and since they did not understand the
coarse humour of the seventeenth-century Europeans

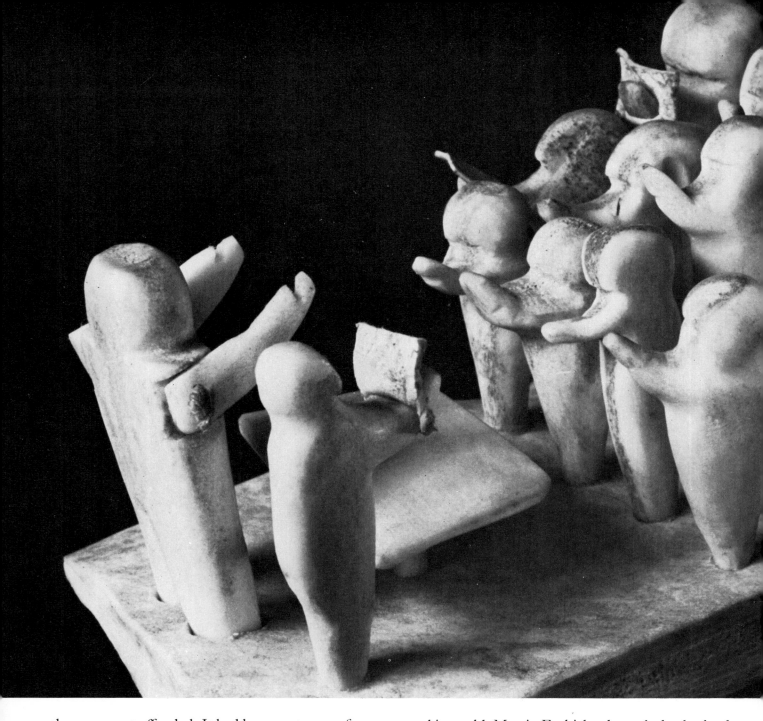

they were not offended. It had been customary for uncountable ages to offer sexual consolation to visiting strangers. It was a two-way exchange of happiness of great value in the lonely and emotionally depressive conditions of the arctic nights. It was all so natural that Eskimo art has only a very mild erotic aspect. Neither can it be said that the seventeenth- and eighteenth-century Europeans were any cleaner than the smelly wild Eskimos. Such contacts between exploring expeditions from Europe and the Eskimos were rare and not the occasion of much cultural exchange. Some Eskimo ivory carvings found their way to cabinets of curiosities; some European knives came into service among the Eskimos.

The first explorers of the Eskimo lands were seeking gold. Martin Frobisher brought back a load of black earth which was thought to contain gold. It had been accepted by many intellectuals of those days that the *materia prima* from which gold could be extracted would be earthy and black. It was one of the basic assumptions of alchemy. Expectations were aroused, so there was little difficulty in equipping a larger expedition to Labrador to bring back more of the mineral. Alas, the assayers found so little gold that refining was not worth while. Yet the search went forward, on a strictly commercial basis, hoping for the enormous expected profits from a pirate-free north west passage to Cathay. In search of the vision of clear water, travellers faced the icy terrors, discovered Ungava and Baffin Island and the great

bay where Hendrik Hudson died with his son, abandoned in a small boat.

To those early explorers, the Eskimos were only incidental events, strange people who lived marvellously in the ice. They were thought of as cunning fighters who were bold and bloodthirsty. The sailors knew nothing of the tragic history of the old Viking settlements, but the echoes of those times lived among the Eskimos. French fishermen also contacted the Eskimos in the east, and there was the same mixture of trading for furs and fighting. Each side had possessions which were worth stealing if the opportunity offered. However, at the dawn of the seventeenth century it seemed that the white man would not try to pass the ice barriers of the northern

seas. The same barriers were the homeland of the Eskimos, the hunter's land of happiness and survival.

In the far west the story was similar; Japanese and Russian fishermen saw the Aleuts, and occasionally penetrated beyond to the more truly Eskimo settlements. But there could be no true meeting of minds and the total result of such contacts were a few folk tales, and the possession of some iron knife blades which the Eskimos had obtained through barter.

The first period of European contact with the Eskimos had little effect upon their lives. The ancient ways continued. The trading posts set up by the Hudson's Bay Company were of some importance as points where hunters could exchange skins for knives, but their contact with the Eskimos was much less than with the Indians of the southern areas beyond the Bay. Trade followed the forests and lakes where there were more valuable skins for barter. As for ivory and sealskins, the whalers were soon supplying the markets of Europe without any great necessity to trade with the small groups of Eskimos they met on their wanderings. The important contacts in those days were peripheral, some in Alaska, but mainly on the Atlantic seaboard of Labrador and Greenland.

The most important single event in this area was the missionary work of Hans Egede who worked in Greenland from 1721 to 1736. He began Eskimo education, and opened up the world of the white man in a friendly way. A little later, the Moravian Brethren came to Labrador. The missions with their good intentions and hard words produced only local effects. Some Christian symbols carved in ivory were made, but they did not appear outside the shores of the opening of the Davis Strait. Like all other Eskimo communities, the people were isolated by great distances one from another. The missions were foci of trade and became organised villages where people could find a living. But there was no incentive to seek out other Eskimos, no normal contact. As had been the case for thousands of years, this widely separated people retained much of the basic arctic culture, but developed as individual communities. However, by the mid 1860s Eskimo life was gradually changing through contact with the white men, the kabloona as they called them. Animals were being hunted for commercial reasons, and the ideas of the foreigners brought new influences on art and life. Only very remote people escaped it. The end of the Thule culture was approaching and a new way of Eskimo life was imminent.

44 **Singing psalms** by John Polik. Bone (6.3 × 10.8 × 6.3 cm). Eskimo Point, N.W.T., 1966. (Collection: Mr and Mrs D. F. Wright, Ottawa)

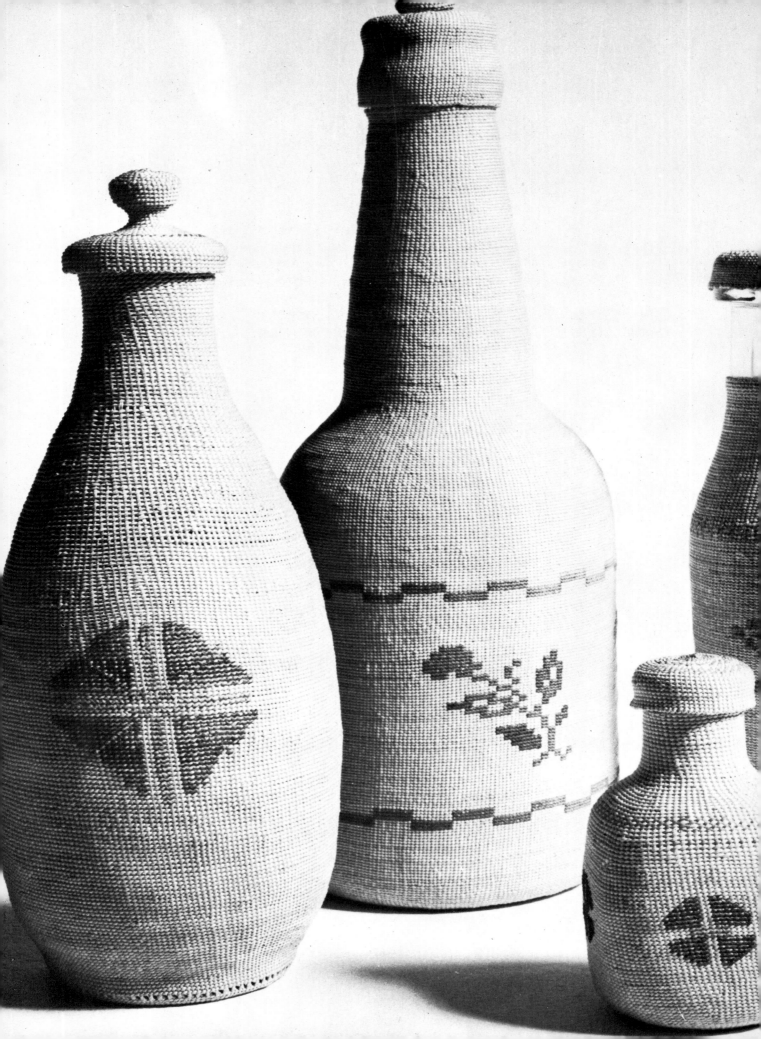

# The Changing Arctic

The nineteenth century was a period of total change for the people of the northlands. The climate was becoming slightly warmer, and sea hunting became easier, but also the improved conditions revived the European search for a north west passage to Asia. The economics of Europe were changing and the greatly intensified search for trade included an increase in the fur trade. Most importantly of all, the United States of America was now a nation with an expanding population and all the needs of a civilised state comparable to the Canadian Dominion of Queen Victoria.

The Canadian arctic was the scene of many British exploring expeditions organised through the Admiralty. No doubt some strategic considerations influenced the mapping of the arctic, but in fact much of the work done showed the devotion of the leaders to pure science. The reports of the Parry Expedition, so well illustrated by drawings of people as well as maps, have given us a marvellous understanding of Eskimo life of the 1820s. The exploring expeditions were also of some interest to the Eskimos. They introduced new ideas, and gave an opportunity for trade, and for acquiring guns which helped the hunters. That hunting was likely to become destructively successful was not envisaged by either side. The Eskimos were still hunting only enough for their needs, but little by little those needs extended to the acquisition of skins for trade with the Europeans.

There was a certain equality between Eskimos and strangers, since, although the visitors possessed marvellous things, they were unable to support themselves in the arctic if they lost their ships. The melancholy fate of Sir John Franklin and all his expedition was watched by Eskimos over the few years which it took for all to die. Some of them were helped by groups of Eskimo hunters, but they moved on trying to reach some distant port where they would be rescued. But there was no success, and in later years the local people took other sailors to the graves of those kabloona whom they had buried. Such a tragedy made it quite clear that only the Eskimos could be safe in their world of ice.

However, the explorers were soon succeeded by ships of whale hunters. The growth of the civilised world whence these strange men came was now impinging on the arctic. Whalebone for corsets, sealskins for coats and muffs and ivory for ornaments were all sought after and became the source of much good to the Eskimos who often worked for reward on ships and brought furs for exchange. Alas, too often they made the exchange for whisky and put themselves out of action while indulging their passion for the strange vision-bringing liquid. But their great tragedy came when the whalers responded to the call for more oil for lighting and for foodstuffs. At the turn of the century a cheaper substitute for butter was needed in Europe. The population increased during the Industrial Revolution in numbers but not in riches. A great deal of research went into turning whale oil into the new margarine. The result was not starvation for the Eskimos but an increasing market. And that in turn meant the establishment of larger groupings of villages at suitable places both for hunting and trading with the people from the big ships. Once more the wide spread of the arctic meant that many groups of Eskimos were not in contact with the strangers, but little by little new trade products, needles, metal tools, stoves and so on, became current utilities in the arctic.

This increase of contact in the Arctic Ocean was partly due to climatic improvement, and this had continued in Greenland until, by the mid nineteenth century, conditions were almost as they had been in the times of the Norse settlement at Brattahlid. Greenland was politically part of Denmark and trade with Danish ships was steady. The difference was largely that the Danes were first to try to assimilate Eskimo culture into European ways. Small towns grew up as centres. Missionary schools were followed by state schools. By the middle of the nineteenth century a newspaper was published in Upernavik using the Eskimo language. A local artist made a series of woodcuts to illustrate a little book about the end of the Norse settlements in Greenland. The population of southern and eastern Greenland was small but it had achieved a new northern way of life

**45 Aleut baskets.** The Aleut tradition of weaving small baskets and cases was stimulated by the demand during the 19th-century gold rushes. But it is now a dying art and examples are much sought after by collectors. These four baskets, covering bottles, are woven of grass with embroidery thread for the patterns. The tallest is 20 cm high. From the Aleutian Islands, early 20th century. (University of Alaska Museum, College, Alaska)

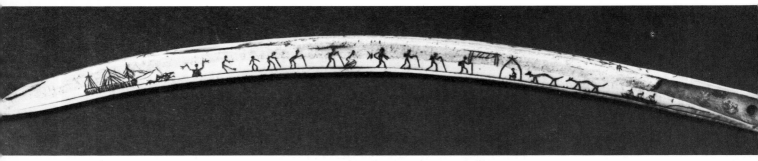

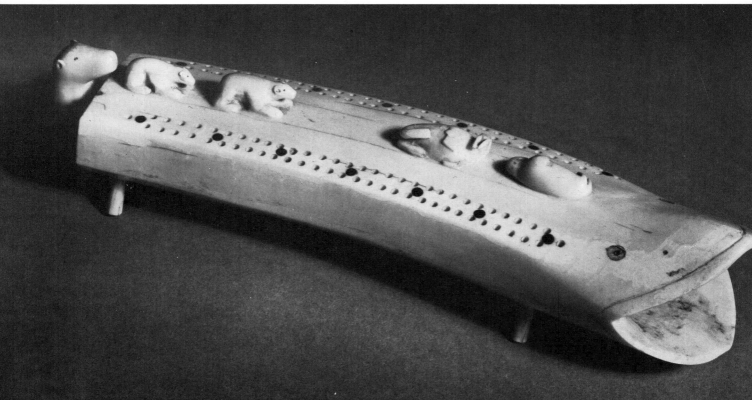

47

which was completely viable in the new world situation. Hunting and fishing were the mainstays of the commerce of Greenland, but at the same time Eskimo people were visiting Denmark and discovering much about the European at home. The artists were finding a market for occasional ivory trinkets and beautiful household ornaments. There were no great quantities of such works, but they were available and much enjoyed. Part of the change came from the fact that the Greenlanders were now Christian church members, and the old magical spur to art production was largely discounted. Hence there was no reticence in displaying abilities. Also there had been a general adaptation of costume in which European woollen garments were joined with the ancient skills in leatherwork to produce something typically Eskimo, yet of the newly developing world. In the late nineteenth century, Europeans found the Greenland belles quite exciting, displaying well rounded thighs dressed in delicate leather tracery at

the top of long boots. In their homeland the Europeans were still deeply stirred at the sight of a lady's ankles. But the Greenlanders did not bother; they had managed to adapt the utility of Eskimo clothing with elegance and beauty in their own way. In Greenland a composite culture was growing of which all the main elements were Eskimo. Yet such was the difficulty of the terrain and the vastnesss of the silent ice that no one was then aware of the Polar Eskimos still living their ancient hunting life at the other end of the great island. The material basis for a rapid development of the whole Eskimo population scattered around Greenland was not yet ready. However, in the south, around Angmagssalik in the east, and at Upernavik in the west, art was flourishing in a new context in Eskimo life.

The Siberian Eskimos, though few in number, had learned much from settlers from Asia who had brought designs of Russian folk art with them which suited their taste. They were also in contact

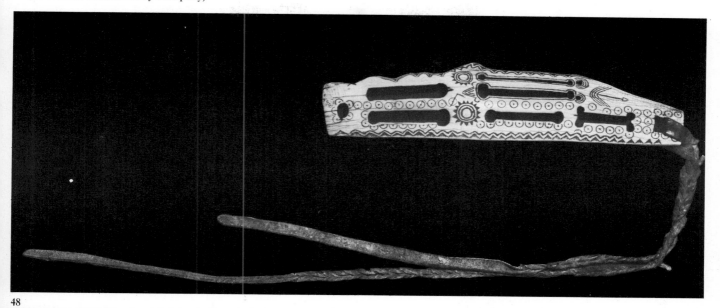

48

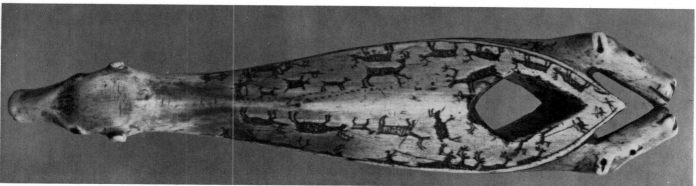

49

with the Chukchi and traded with them for tobacco pipes and for carving. In this area they had a rather unusual supply of carving material in the mammoth tusks which were sometimes exposed when the spring floods washed down clay and gravel banks. It would seem that the Siberian Eskimos, although few and isolated, were probably a westwards travelling group in ancient times from the American side of the Bering Strait. In historic times they had been in close contact with the whaling fleets in the Pacific, and developed the scrimshaw work they had learned from the sailors to a high degree of illustrative realism. In part this was an art for exchange with the sailors, but it also illustrated the themes of the stories and songs which were sung in the community houses during the winter. The elegance and beauty of their work made it very acceptable to the sailor and the diplomat. These Eskimos had a long contact with traders, and they had become fur trappers as well as hunters and fishermen for their standard subsistence.

The Eskimos of the west coast of North America also saw great changes during the nineteenth century. The Aleuts of the Bering Sea area had been in contact with other peoples for centuries: Japanese fishermen, exploring navigators including James Cook and the great Admiral Behring after whom the Strait was named, and Kotzebue whose interest in native artefacts resulted in a fine collection now in the Hermitage Museum in Leningrad.

The explorers had been followed up by the Russian government and the Orthodox Church, but the desolate lands of Alaska seemed of no great importance, and in 1857 Alaska was sold to the United States of America. By this time there were many ships from the United States and Canada cruising after whales, and it was in this sector of the Eskimo lands that the local people learned the art of scrimshaw decoration by engraving the surface of ivory and rubbing lamp-black into the lines. Some of their Thule culture ancestors had sometimes engraved

45

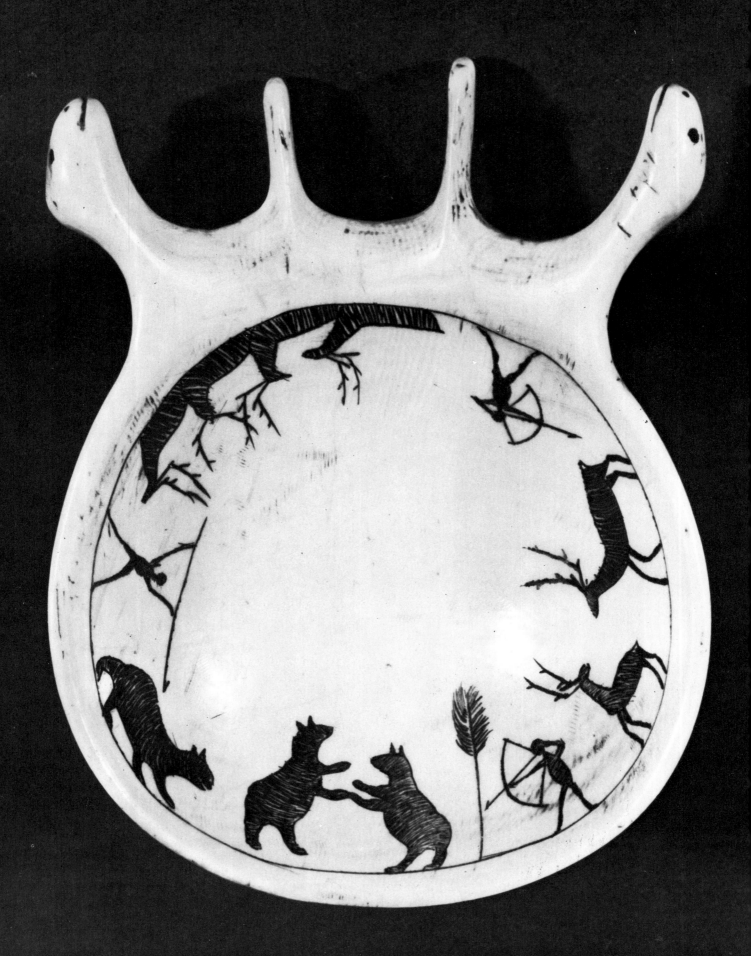

little pin-men figures in a very formal way, but this new art inspired by the spare-time art of the sailors encouraged individual self-expression. A new quality of scenic representation was achieved, and seal-ribs used as bows for bow drills became picture galleries of Eskimo life. Eskimo scrimshaw work does not necessarily reflect anything of European culture or religion. Most compositions are accounts of Eskimo living, and some show records of shamanistic magic. The spirits and non-material creatures take form but they are the same beings described in the ancient folk tales of the Eskimo. Naturally the Christian converts made some kind of religious art, simple and sincere works, often pendants and ornaments for Christian use.

Not all contacts between Eskimos and whalers were sweetness and light. There were raids and murder on wrecked ships, stealing of canvas to replace sealskin for the summer tents, and a new development of begging from the richer strangers. But the saddest blow to the Eskimos was the introduction of cheap whisky which became, as so often with people new to intoxicants, a dangerous curse. The desire for it induced cheating on both sides, and the effect was often dangerous, as when a group of islanders of the Bering Strait once went on a drunken feast and failed to bring in the autumn seal meat, so that in the following winter many died from starvation. Nevertheless the American Government was not unmindful of its protégés in the far north west. Some attempts were made to help the local people to set up trading stations, and little by little schools were established.

The nineteenth century was one of change. In its course sailors and scientists added immensely to the world's store of knowledge about the Eskimo people. The great museums of the world have fine carvings and objects of everyday life from all the regions of the arctic. Some of them belong to the world of culture-contact and reflect the desire of the Eskimos to adopt something of Western living styles. There are also works which were made for exchange, some to amuse the sailors and others to go to the homes of white people who began to feel the charm of Eskimo art. They were good work, and honestly made, but they were falling between two ideals. They were neither the old magical art which assisted the hunter nor the highly paid art which expresses something of the inner personality of the artist. The level reached was simply of representation.

It is the everyday objects which were decorated with pictorial history and mythology that tell us most about Eskimo life in the nineteenth century before Eskimo culture was greatly changed. They show us that the shaman was still an important member of society who was at once here and also in the world of the spirits. His position was socially important, and it often brought wealth in the shape of presents of food and garments as a reward for his information and his skill as a healer. It was never, however, part

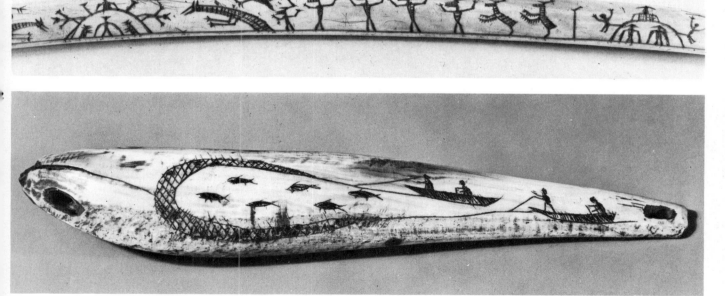

50 **Spoon carved from a walrus's shoulder joint,** engraved with hunting scenes. (6 cm wide). From the Canadian arctic, 20th century. (Staatliches Museum für Völkerkunde, Munich)

51 **Ivory bow drill** engraved with a scene of a shaman in his hut charming caribou spirits for the hunters. Probably from the Canadian arctic, 19th century. (Museum of Mankind, London)

52 **Ivory net weight** in the form of a fish, engraved with a scene of fishing with a seine net. Probably from the Canadian arctic, early 19th century. (James Hooper Collection)

47

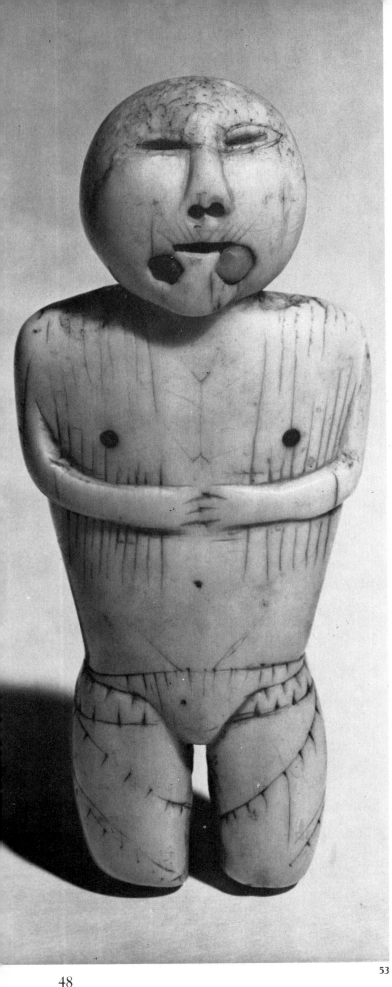

of Eskimo ethics to respect wealth and even a rich
shaman would feel it incumbent upon him
occasionally to distribute his wealth among the
neighbours. The angakoq, as he was usually called,
had a considerable influence upon art. Even when he
was not a carver himself, his descriptions of the spirit
beings whom he encountered were of great
importance to the artists in the community. His
personal equipment also was much ornamented with
carvings. In some areas of Alaska the angakoq wore a
painted wooden mask, related to those used by the
neighbouring Indian groups, though in the use of pale
colour and long elegant outlines the Eskimo tradition
was strongly marked. In northern Alaska a few
'frame' masks still survived, in which the angakoq
surrounded his face with figures and symbols in a
framework. His equipment also included cases for
catching spirits who were to be banished, pendant
animal shapes to aid his skill in making contact with
the souls of the creatures, and ornaments for his
magic drum. The angakoq was by no means a
political power among the Eskimos; he was just a
person endowed with special powers, which often
made him rather unfitted to be a great hunter or a
leader of men. His frequent dissociation of personality
made him unreliable in the ordinary sense.
Nevertheless, the community would be greatly
inconvenienced without the presence of its seer and
prophet. Women could achieve eminence in the field
of magic, though they were less common than men
in the groups of shamans who would meet if
opportunity offered. Like the men, they carried their
little bags of magical objects, often ivory and wood
carvings representing spirits, and usually some false
fangs which could be slipped into the mouth and
extruded to add to the audience's impression that their
shaman was possessed by some strange animal spirit
while in trance. It would never do for an angakoq
to fail to produce phenomena, and therefore all were
prepared to use straightforward conjuring tricks to
impress their audience. However, many instances are
recorded of shamans predicting events, divining the
presence of lost property, and of dreaming true
visions. They were not usually people who suddenly
decided they were possessed by spirits. Normally the
young angakoq went to a learned specialist and
studied the arts of drumming himself into a trance
state, and of contacting the spirit powers. Fees were
paid in kind, and the junior became a veritable
sorcerer's apprentice, serving the master with
devotion, assisting both in the meditations and in the
manufacture of impressive phenomena.

The angakoq was not unique in Eskimo society,
since any member of a community might receive
messages from the spirit world. On the whole, people

48

53

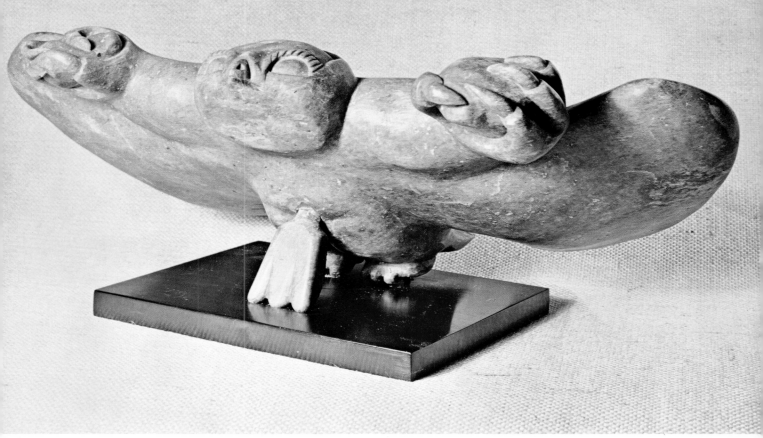

54

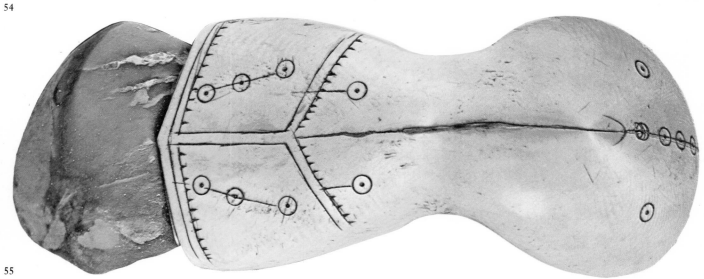

55

53 **Shaman's charm.** A human figure of ivory inlaid with stones (13 cm high). From Banks Island, Alaska, 1800–1880. (Museum of the American Indian, New York)

54 **Mythological giant owl.** Green stone. From the Canadian arctic, 20th century. (Gimpel Collection)

55 **Jade scraper** used as an adze for preparing the surface of wood. The grip has been shaped to fit the fingers of the carver. Mammoth ivory haft. Probably from the Canadian arctic, 19th century. (Museum of Mankind, London)

**56 Wooden dance mask** with features of man and seal, painted green, red and white. In shamanistic performances the heads of spirit beings are often seen emerging from the mouth of the shaman. From Alaska, late 19th century. (American Museum of Natural History, New York)

**57 Wooden paddle** painted with scenes of a walrus hunt. From Alaska, late 19th century. (Museum of Mankind, London)

56

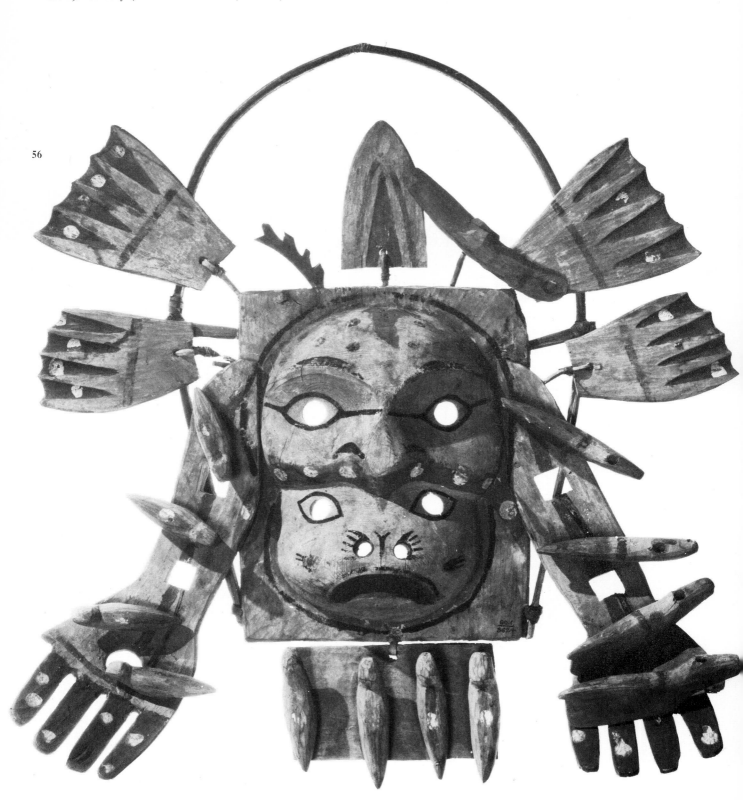

were afraid of the recently dead, and a great deal of trouble was taken to ensure that a relative died away from the home if possible. This might well lead to a speeding up of death, but all the same it is clear that the Eskimos were a kindly, affectionate people and cared for the sick and old until the end became inevitable. Well after death the spirit was thought to have a care of relatives, and to dream of the dead was an indication of their interest. To see visions of dead relatives was frightening, but sometimes such apparitions were indications which helped the hunter in the pursuit of game. In general, the ghostly visitation was thought of as either good advice for the hunter, or as a warning which must be heeded. It may well be that most of these visions arose from the inner personality of the individual seeing the vision, but they were accepted as real occurrences deriving from other living beings.

Every Eskimo had some personal spirit protector. It often took animal form, and was acquired in late childhood through some circumstance in which the animal appeared to help. There were initiation ceremonies for youngsters but they were not like the ordeals of loneliness undertaken by the American Indians to the south. The reason was that the arctic terrain usually meant that a lone journey in search of inspiration would result in death. In the Alaskan area the onset of puberty would mean that the boy would separate from his family and find a sleeping place in the communal house used for group activities in the settlement. In other regions there were ceremonies and some segregation. Girls were universally separated from the group for their first two menstrual periods. The ceremonial separation was a signal to the community that the girl was marriageable and that her parents would welcome enquiries with a view to marriage. These rites of passage from childhood to adult status were important though not marked by the ceremonialism of more favoured regions of the earth. Vitality, sex and procreation were linked as a kind of spiritual development. The dreams and visions natural to the period were taken to be the advice of the spirit world, and it was hoped that the ancestors would be concerned. In many communities it was the custom to name the newest baby after the last deceased member of the community, and there was said to be a spiritual bond between them, though reincarnation was never a formalised belief.

Of course all living beings had souls, both men and animals. One soul was immanent in the body, directed all living action and continued the thought of the person throughout life. At death it usually faded away to be replaced by its duplicate which had been present all the time but began a really independent existence at death. Any person might become separated from his soul in illness, when the shaman would be called in to capture the wandering spirit and return it to its proper body. But also any person might dissociate in sleep so that the spirit could visit the place of the ancestors or the realms of the animals and return to the body when awakening. The information obtained in the dream, if remembered, would influence the conduct of daily life as if it were a real waking experience. Experience of the supernatural was common, a phenomenon which perhaps could be expected under the circumstances of arctic life. The separation of the hunt and its excitement for the men was equalled by the importance of the work around the house felt by the women who were always busy and always a little anxious. The mysterious advent of storm or fog passed across the people and no one was quite sure whether the apparent was quite real. The idea of enchanters who took the forms of seals to delude the hunter, or of sea spirits who lured young men to their doom, was as real to the Eskimos as to any medieval European peasant; only to the Eskimos these events might occur in reality at any time.

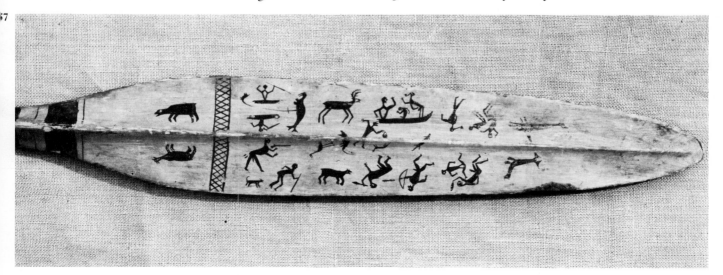

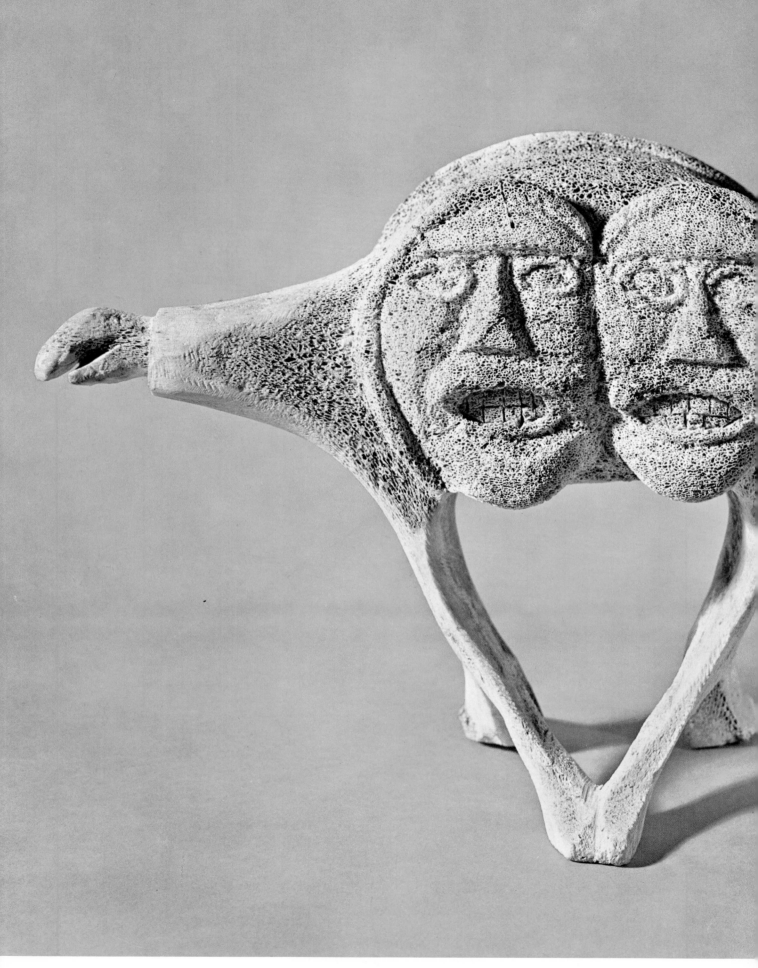

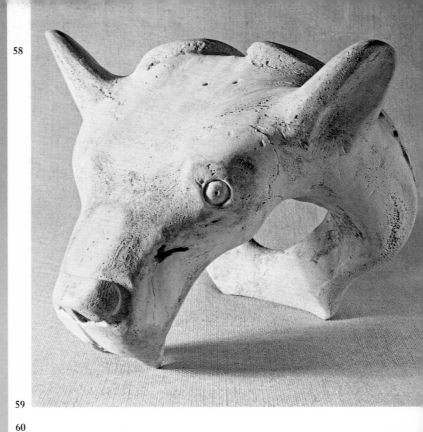

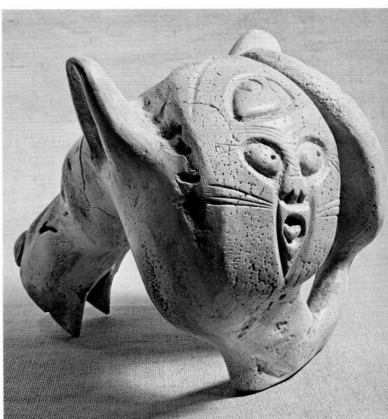

**58 Good spirit** by Manasie Manaipik. The carving conveys the idea of a dual personality in one body. Whale vertebrae ($32 \times 48 \times 19$ cm). Pangnirtung, N.W.T., 1969. (Collection: Macmillan–Bloedel Limited, Vancouver, B.C.)

**59–60 Bear spirit** (back and front views). The human face on the back is the feminine one of a pair of heads. Whale vertebrae. From the Canadian arctic, 20th century. (Gimpel Collection)

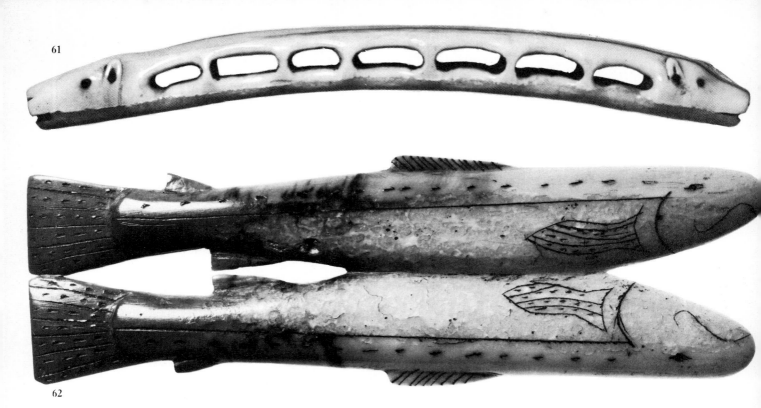

61

62

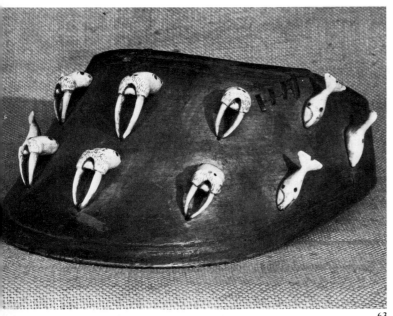

63

61 **Dog harness terret** carved with dogs' heads. (The terret separates the reins of the dog team). Walrus ivory (14 cm long). Western Eskimo. Acquired 1903. (Royal Scottish Museum, Edinburgh)

62 **Handle** carved as two conjoined fish. Used as a grip to hold a seal or fish line. Walrus ivory (11 cm long). From Nunivak Island, Alaska. Acquired 1957. (Royal Scottish Museum, Edinburgh)

63 **Eye-shade.** Birch wood and walrus tooth, stitched with baleen. Aleut, mid 19th century. (Museum of Mankind, London)

64 Group of ivories: **Walrus ivory snow knife** depicting a whale and walrus hunt; **Harpoon rest from a kayak; Two toggles** in the form of seals; **Fishermen's charms,** used to divine the outcome of an expedition. All from Alaska, 19th century. (Museum of Mankind, London)

The Eskimos expressed their practical and spiritual attitude to life in their involvement with ivory carvings and bone sculptures which combined usefulness with magic powers. There was usually no point in trying to make a large sculpture. It had no functional use. The angakoq might need a mask for ceremonies, or perhaps a tusk carved with little masks which represented the spirit world, but the ordinary hunter needed harpoon heads, toggles for affixing his weapons to the kayak or sledge, little fasteners for sealing floats, and wound plugs to stop up the weapon holes in slain seals so that the bodies could be towed behind the kayak. There were also toggles for fixing carrying straps for dragging home the game. Dog traces, too, had ivory fastening buttons.

Most of the work of making these things was done in the winter months when game was scarce and the daylight was gone. Then in between occasional festal gatherings of the community, the men would carve and polish the things they needed for life. Their tools were of the simplest, and a century ago were still mainly of flaked stone. Each object was scraped into shape and then abraded to final form and polished. The later Eskimos were more interested in smooth surfaces than the Dorset people who were their ancestors. So they spent a good deal of time abrading the surfaces with whatever stone was available and then gently polishing with fat and their hands. It took a lot of time, but an object when carved was improved by handling and fondling from time to time. It made a kind of personal contact, and produced a form of beauty which was appreciated by the family. A wife was as proud of her husband's tools as he was proud

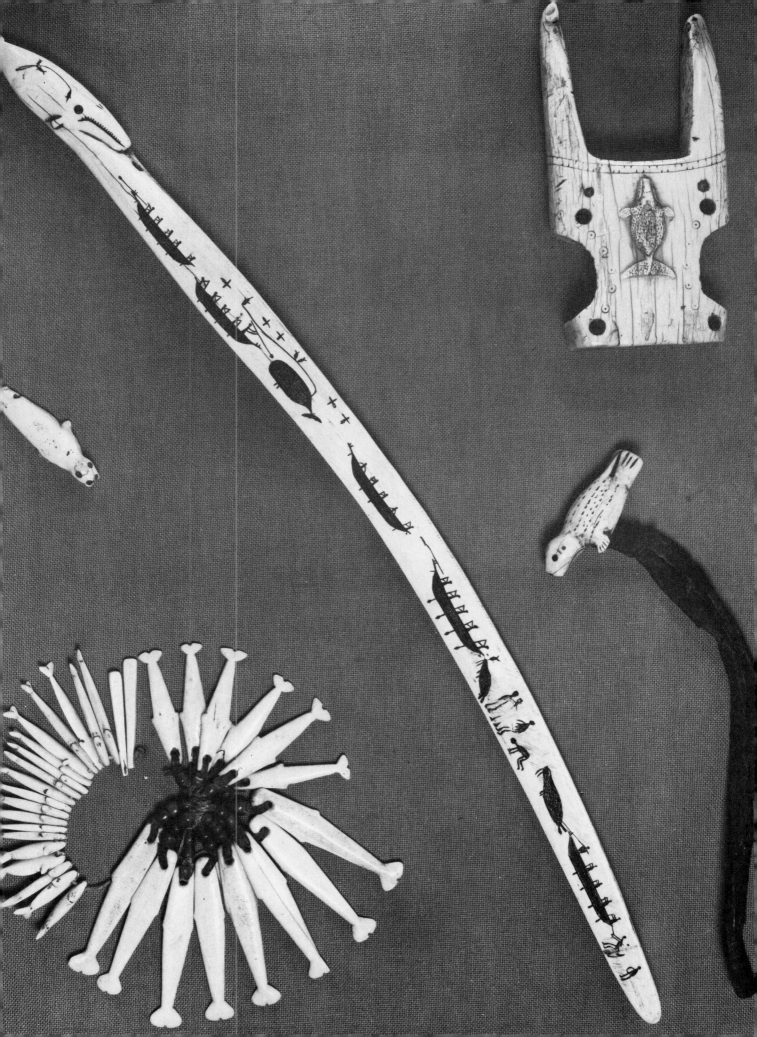

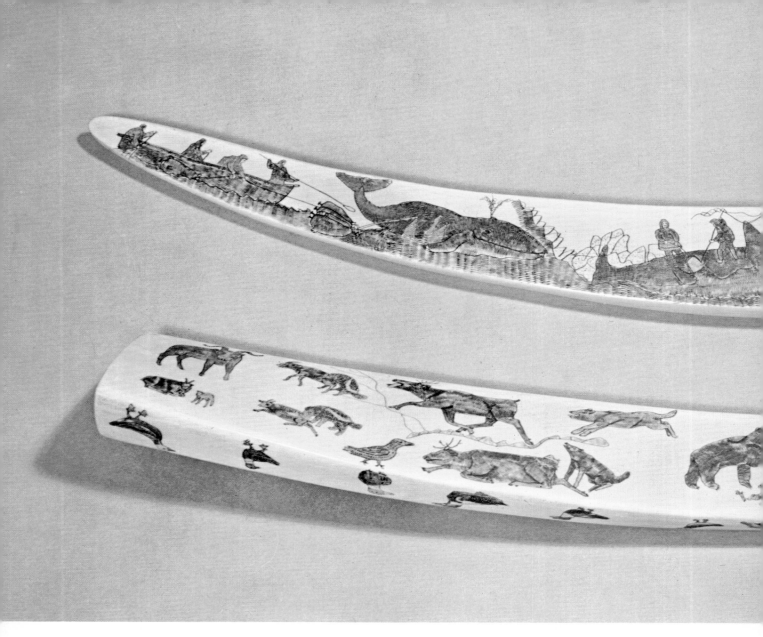

of the fine fur clothes which she made for him. In turn he made her a needle-case, and thimbles. Anything at all might take on an animal form or present a surface for decoration. The beauty of form and colour was appreciated in the community, but suitability for the purpose of practical use was the real point. It was a matter for the artist personally to choose whether the form he used represented a protective spirit being. It might be a bear or a fox, or a bird; all might be helpers of human hunters who were in spiritual contact through the world of souls. Hence we find much in the practical arts of everyday life that has a real quality of life within it. It is also invariably easy and pleasant to handle in use. Simplified forms were important because most of the toggles, harpoons, and spear-throwers were handled in practice under conditions where the hands could not be bare for fear of frost bite. Everything must be smooth and easy to guide into place.

Indoors the simplest things were shaped for use and so acquired beauty. Simple net gauges and netting needles were rarely decorated beyond a few incised lines, but they were well placed and acceptable. Implements such as handled flaking tools for the blade maker were fitted with plain or carved handles of good shape. Combs were important articles of adornment as well as cleanliness, so the flat surface above the teeth formed an area which had been beautified from the earliest times. Eskimo forms included outline figures and scrimshaw scenes. The subjects usually conveyed to the artist the idea of good fortune. Powerful tools, such as the perforated ivory levers which were used as arrow straighteners, were carved with fortunate symbols of the quarry the arrow was expected to bring down. Among these, seals, polar bears, and caribou were most important. Sometimes, as in Palaeolithic Europe, the whole object represented the desired animal; sometimes just the head of the animal was represented, and the body of the instrument was engraved with magical themes.

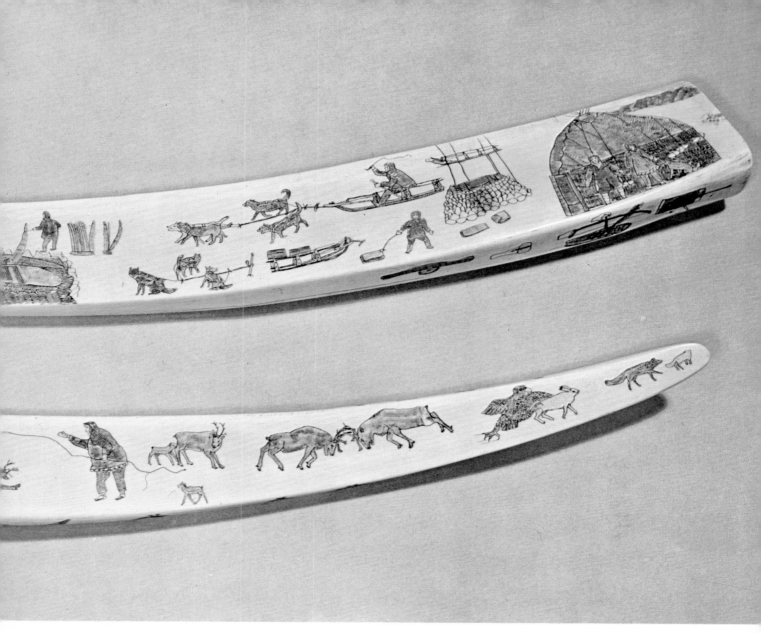

In some of them we find pictures of magic in which magicians turn into caribou, or caribou spirits become birds. They are strange but direct pictorial works which stem from an absolute acceptance of the beliefs they illustrate.

Women were involved in the arts quite as naturally as men. They might paint pieces of woodwork, or make a kind of embroidered leather stitchery on their needlecase flaps. Each woman made clothes for her family according to the local fashion, and she chose furs which were not only practical but of colours and tones to make decorative borders to the garments. Sometimes she added short fringes of skin, or pendant strings of fish vertebrae. The results were often of great beauty. Styles varied from place to place and the two sexes had differing costume, but it was an honour to a woman that her menfolk were splendidly dressed in efficient hunting costumes as well as in outfits for life in the village where they might be present at community dances. For themselves, the women spent even more time on wearing the most elegant of fashion in clothing. Styles differed from area to area, but in each place the quality of the sewing and the choice of furs was of great importance. Since they were less outdoors than the men, they were able to indulge in some coquetry. In Greenland the areas between the top of the long boots and short trousers were often left bare so that the soft brown thighs could be seen. In harsh conditions little wraps of white fur covered the bare patches. Elsewhere the jacket was deeply scooped out at the sides so that an area of midriff above the hipster trousers was left bare to emphasise physical attractiveness. The great hoods in which the babies were carried could be adjusted to show a glimpse of bare shoulder, and faces, often strangely beautiful, were decorated with

---

65 **Walrus tusks** engraved and tinted with hunting and whaling scenes. Siberian Eskimo, late 19th century. (Collection: Hudson's Bay Company)

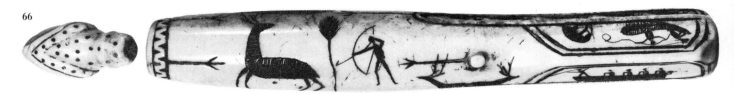

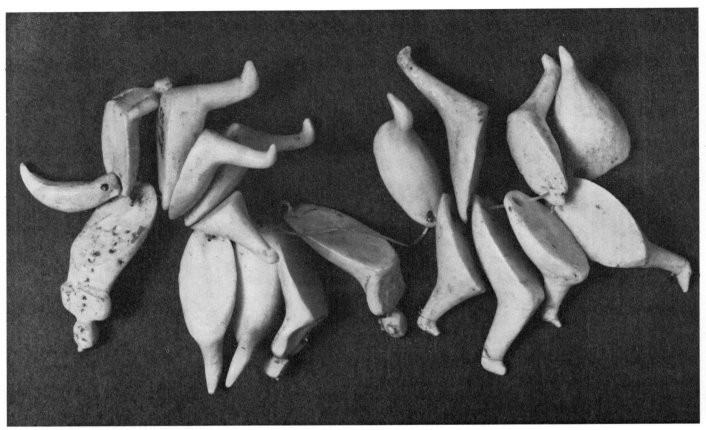

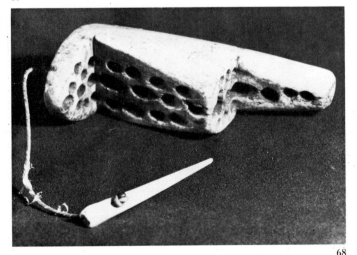

68

66 **Needlecase** of walrus ivory engraved with hunting scenes blackened with soot. Note the rare depiction of a tree. From Alaska. Acquired 1901. (Royal Scottish Museum, Edinburgh)

67 **Ivory gambling counters,** including geese, swans and mermaids. 19th century. (Museum of Mankind, London)

68 **Ajegaung,** an Eskimo game in which the object is to jerk the peg so that it falls into one of the holes. Whale bone (10.5 cm long, peg 7.5 cm). Baffin Island, 1911. (Anthropological Museum, University of Aberdeen)

lines of tattooed dots across the cheeks or below the lips.

Indoors, in the heavily insulated and overheated winter houses, whether of stone or wood or snow blocks, most of the old-time Eskimos went naked. In parts of Alaska tiny cache-sexe hip strings were used by men, though rarely. In Greenland the girls often wore a tiny cover for their pudenda, but this was as much an ornament as an adjunct of modesty. It was very elegantly embroidered and many specimens were decorated with pendant chains of fish spines. However, clothing was rare for indoor occasions, and sexual behaviour was natural so that Western ideas of decency or taboos of the body were not of any importance until the days of close contact with Europeans and religious missions. But it should be noted that the introduction of different houses had more effect on outward modesty indoors than any change of belief.

Sex was not overtly expressed in art except for objects associated with some of the festivals for the changing of the seasons, particularly those before the hunts began, for then it was important to bring nature

into a creative mood, so that animals might more freely copulate with fruitful results. In Alaska in old times there was a spring festival in which young men wore masks and carried around bone or ivory penes strapped to their bodies, but this was rare.

Many of the little naked ivory figures of men and women are simple and modest in nature. They were often used as charms to be put under a woman's pillow so that her children should be beautiful. The sex of the figure was meant to indicate the desired sex of the baby to come.

Life was all of a unity to the Eskimos. Women were quite as important as men except that too many girl babies were sometimes a liability since they would not grow up to be hunters. But the balance of work within the family was nicely adjusted to the relative strengths and temperaments of the two sexes. On the whole the occupations in and around the home were those for women, and the hunting and journeying were those for men. But this is only seen in art in the design of clothing. Early carved human figures rarely showed people at work, though the introduction of the art of scrimshaw was the occasion of many linear pictures of everyday life. Here the themes are mainly factual, and the sexual elements are rare, though they occurred sometimes with magical connotations.

When we consider all the objects of an Eskimo household, it is clear that the production of works of art did not take up a very large place. It was an adjunct to the useful arts, and was mainly a product of life through the terrible winter night. The purposes were usually strictly practical, even when magical, and the only really specialised artistic output came with the masks and objects used in the shamanistic performance of the angakoq.

An important aspect of early Eskimo art was the play element. A great many pieces of ivory were carved into birds and animals which rose up from a flat base rather like pictures of ducks omitting all parts below the water line. They were usually of thumb-nail size, often ornamented with patterns of lines and dots, and really most attractive. Their purpose was simply to be used as gambling counters. A handful of the little objects was thrown down on to a skin mat or anything handy, and the value of the throw was determined by the number which fell right way up and those which fell on their side. Games went on for long periods to while away the tedium of the arctic evenings. Great fortunes were not won or lost, though some people became compulsive gamblers. But in a small closed community of Eskimos, all deeply committed to the sharing out of wealth, gambling was not a great problem; it was fun of a fascinating kind. Because it was so popular, the pieces were usually

made with care, and skill was displayed on them. To some extent they were status symbols, for the good craftsman was always respected.

Another very popular pastime which had a great influence on art was the ubiquitous cat's cradle, in which a piece of thong was turned around the fingers to make an outline representation of some object. The designs made were numerous, and usually traditional. Sometimes the strings went only around the fingers, at others fingers and toes were used. Naturally, skill at the game started in childhood, but it was never abandoned, and as life went on skill became more developed, until in old age it would be a delight to teach the grandchildren, and often mystify them by clever development of unsuspected designs. The patterns produced by the criss-crossing strings were not always realistic, but their meaning was instantly recognised by the family in the tent or snow house. The cat's cradle was often chosen to tell a story, starting with a loose loop around the fingers, and building ever more intricate symbolic pictures which illustrated the objects described as the story progressed. A simple myth, like the story of the hunter who chased with his dog team as far as the place where earth met the sky and who can still be seen chasing along as Ursa Major among the stars, was well suited to the string-figure technique. The process of the attachment of realistic interpretation to abstract forms was not a conscious one, but just a natural consequence of the game, but here again there was room for a highly individual interpretation of any abstract form which might evoke one of the figures in the string game. Mostly to the Eskimos the game was the occasion for delighted laughter as one figure followed another on the fingers of a skilled player.

Laughter seems to have been an important characteristic of Eskimo life. Most travellers who stayed with Eskimos noted the child-like glee with which any good fortune or new friendship were welcomed. These people, always living on the icy edge of life or death, were not depressed. There was always something to do, and something to sing over as they worked. Work was hard and often incredibly difficult. Think of the woman chewing a boot sole before making each stitch with her bone needle, or the man sitting for hours beside a seal blow-hole before the time came to make the fatal stroke. To a people living in such a world as the arctic, emotional life was a succession of quiet waiting and exhilarating success. A way of life quite alien to the clean and civilised European brought happiness to the Eskimos. Happiness was enhanced by personal prowess. For the men a reputation as a good hunter or a skilled craftsman was a very satisfying achievement. It was

59

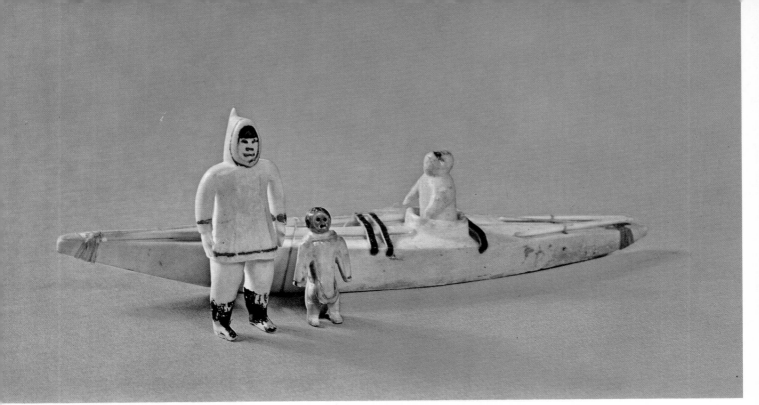

69

70

also very important in the small community, usually of less than fifty individuals, to be able to come to the dance in the community house well dressed in fine clothes. The display of fine things in company, and the ability to give fine presents of food to neighbours because of good hunting, were much prized. In the circle of the winter house where three or four families might live together, industry at work and pleasantness when playing or talking made the cramped conditions bearable. The indoor nakedness led to admiration of physical fitness, and some delight in good tattooing, and it also played a part in the gentle natural forms

of much Eskimo art. Life, humanity and magic were all combined naturally in the traditional art of the arctic people.

**69** Ivories: **Standing man** (5 × 2.5 × 1 cm); **Standing woman** (21.8 × 1.5 × 1 cm; **Man in kayak** (3 × 15 × 2.5 cm). Possibly from the east coast of Labrador, pre 1914. (National Museum of Man, Ottawa)

**70 Woodcut** showing an Eskimo waiting at a blow hole, unaware that a monster is creeping up on him. From an Eskimo book called Gronlandske Folkesagn, 1860. From southern Greenland. (Museum of Mankind, London)

**71 Mother and Child.** Black stone and sealskin (31 × 21 × 19 cm). Port Harrison, Quebec, 1957. (National Museum of Man, Ottawa)

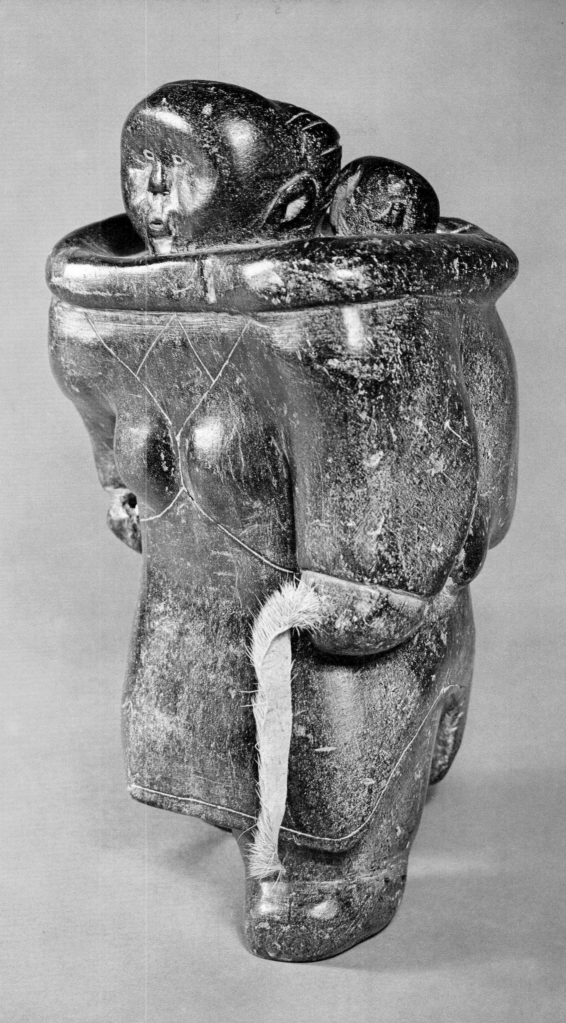

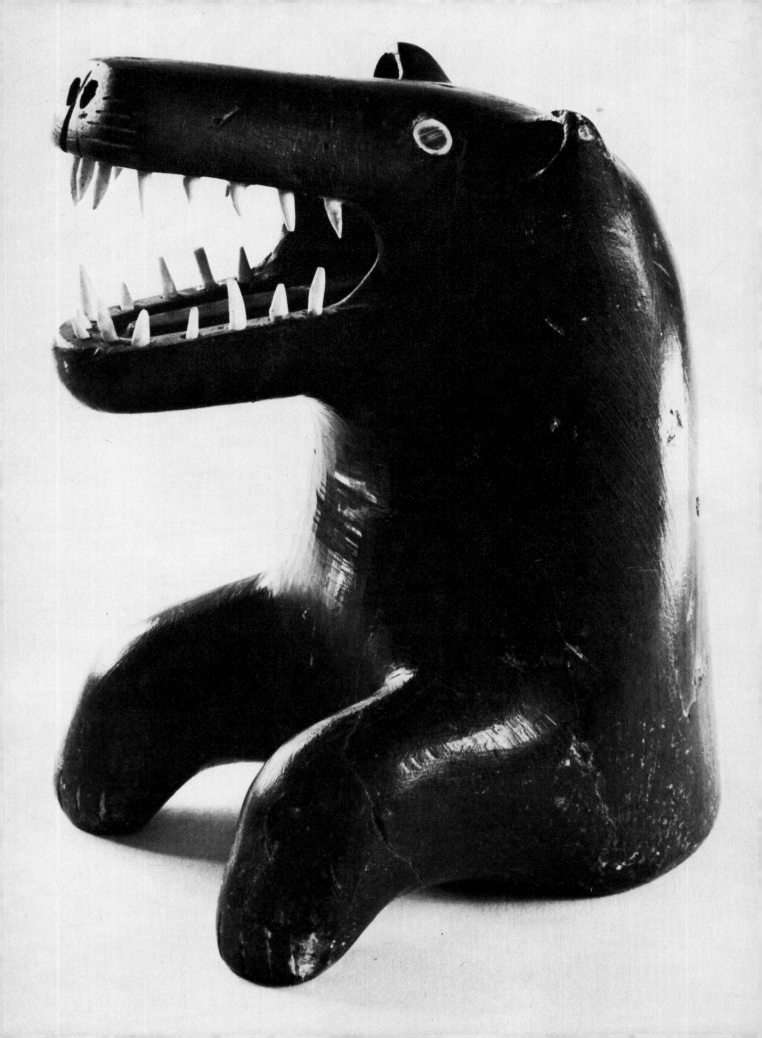

# Modern Times

The nineteenth century began the change; by its end many Eskimos owned guns for hunting, and whole families had travelled on whaling ships and accepted wages mostly in clothing and storage foods. They had begun to congregate at settlements where there was contact with the white men which made up for restrictions in hunting. The continuing improvement of climate had opened more of the arctic to the whales, with the consequent advance of whalers. An unforeseen consequence of contact was the spread of new diseases; venereal diseases became widespread, and smallpox was a scourge, but most terrible of all was the common cold which choked thousands of non-immune victims to death. Governments sent doctors where possible who replaced the primitive medicines of the angakoq. Religious bodies sent out more Christian missionaries who replaced the magic, but did not extirpate the many charming stories of native folklore. Thus, at the beginning of the twentieth century, the forces of change in the arctic were strong and gathering momentum. The Eskimos were everywhere faced with a problem of dwindling food-animals, and of the gradual exchange of hunting for fur trapping. With new wooden houses, woollen trade garments and wooden boats, they were finding some compensation for the loss of the late Stone Age type of life that their ancestors had enjoyed. Life was becoming more strange to the elders, but the younger folk were finding it quite attractive, especially the opportunities of living in larger communities with more human contacts.

Culturally the impact of the technological world has not yet destroyed Eskimo life, but it has altered the framework within which a few families continue to live in the old way but where most have adopted a mixed culture.

For the white man there was a similar rapid change. The old sailing ship was now a steamer. Education had become compulsory, and the great commercial companies spread their search for raw materials much further. The internal combustion engine began to replace the horse; airships lifted into the air, and in 1902 the first aeroplane flew a little way. And, in the north, governments began to realise that they had more responsibility than they imagined for the welfare of the people of the arctic.

Greenland Eskimos, at least in the south and east, made steady progress. They had their close ties with Denmark through the official Trading Company. The missionaries, following up the early work of Hans Egede, were running modern schools, and the people gradually came to live in well-designed wooden houses. The trading contacts were steady, and many families made a living from trapping animals and from sealing and fishing for an export market. Their clothing altered in fashion, not towards European styles, but to a variant of practical arctic clothing of which much consisted of imported woollens. Many spare-time carvers produced ivory carvings for sale, knowing that they would go to Denmark to earn money for their families. A few Danish families living in Greenland established some cattle farming, and Eskimo helpers slowly learned the arts of conserving animal stock for breeding and not for hunting. Change was very slow, and not at all easy for the older people to accept, but it was a change that the Eskimos desired. They were becoming a civilised people in the modern world. Already they could read and write, and a few of their artists became well known as illustrators. But it is to be noted that the slow development of the southern Greenlanders was basically in an Eskimo direction. The kayaks and throwing boards, the eye-shades and summer tents had all remained part of their culture. The arctic adaptations to life were not subverted but simply grew to be parts of a new way of life which more and more tended to exist in small townships of wooden dwellings. The Eskimos had become part of the peoples of the North Atlantic seaboard. Their close ties with Denmark became natural links rather than symbols of domination, and this was due to the common sense and friendly procedures of officials and state trading enterprises.

In the first decade of this century the Greenlanders became aware of their distant cousins, the people of the polar north who were still living in very primitive conditions isolated from the rest of the world at the north western angle of the country. Although their

72 **Head and torso of a bear** emerging from the sea by Amidilak. Black stone and ivory (17.5 × 11 × 14 cm). Port Harrison, Quebec, 1953. (Canadian Guild of Crafts – Quebec Branch, Montreal)

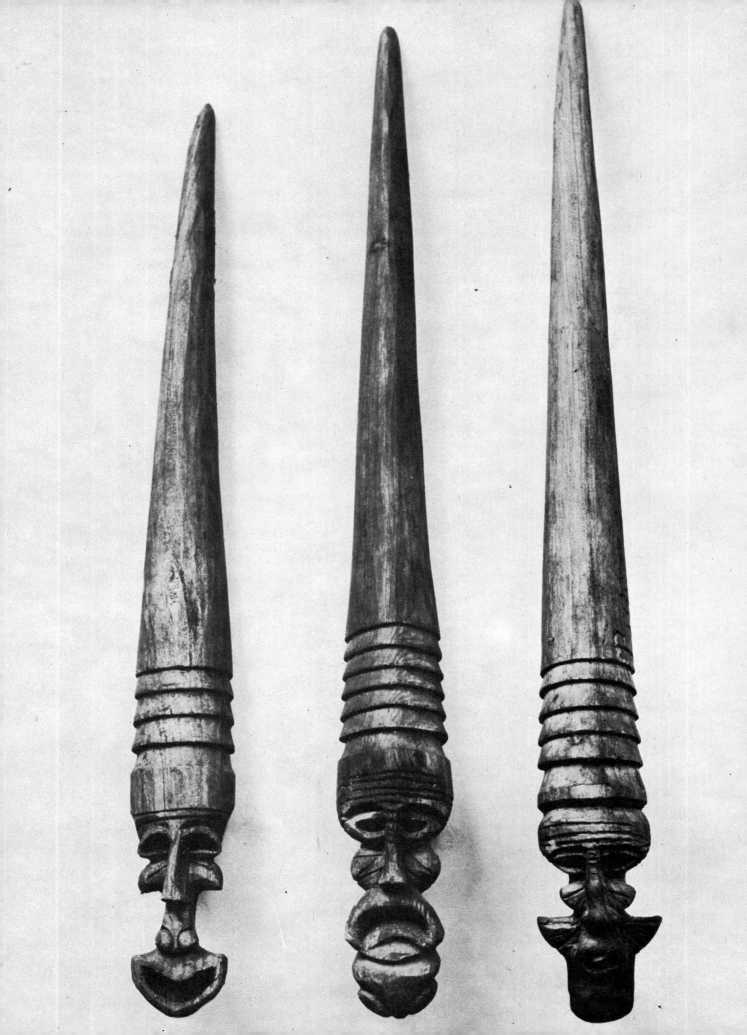

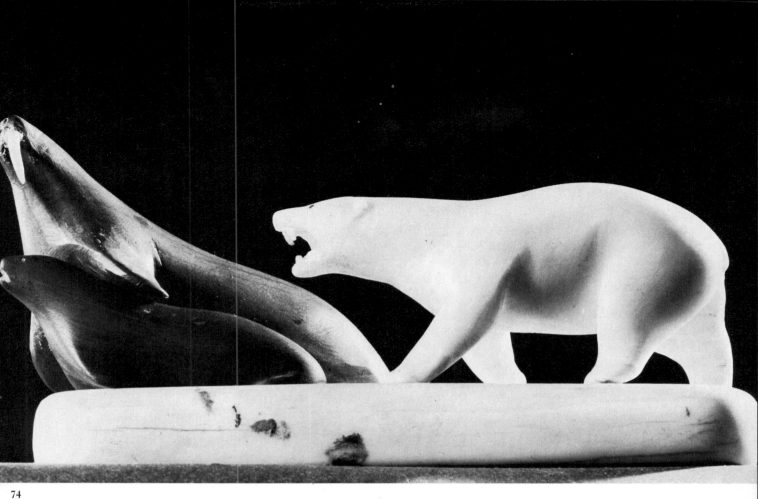

74

primitive type of Thule culture had been influenced
by contact with the migrants from the Canadian arctic
in the 1860s, they were still living in the ancient way,
supporting themselves in all things by ice hunting.

The development of a new trade-oriented way of
life could not follow the same direction in the far north
as it had in south and east Greenland. Conditions
were far too harsh. Not many European or American
products were of immediate value to the people near
the pole. Guns for hunting were the most acceptable
change. But no framed house or organised schooling
was of much use. They were compelled to live in
stone-built huts and in the snow domes when ice
hunting. Everyone, including the children, was
involved in the struggle to win life from the frozen
wastes of the far north.

In 1950 Greenland was changed in political status.
It became an integral part of Denmark, and all
Greenlanders became Danish citizens. The change
helped to unify all the trading developments and the
spread of education. More funds became available for
the slow work of acculturation. Under these
conditions, art among the Eskimo population was
encouraged as a spare-time activity, and there was
some increase in its economic value to the people.
For the polar north, the NATO base at Thule was
a most important change. The Polar Eskimos never
numbered more than a few hundred individuals; now

75

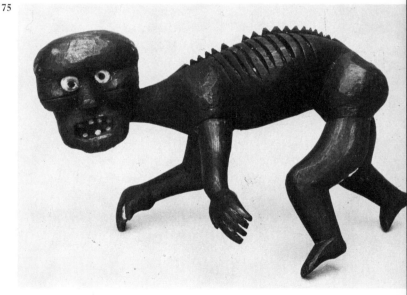

73 **Wooden throat plugs with carved faces.** When a seal is killed,
its lungs are deflated and a plug is inserted into the windpipe so that
it can be more easily towed behind the kayak. The plugs also act
as good luck charms. (Longest 26.3 cm). From Angmagssalik,
Greenland. Collected 1931. (Danish National Museum,
Copenhagen)

74 **Polar bear attacking walrus with young** by Kulaut. Walrus
tusk and steatite (12.7 cm long). Igloolik, N.W.T., 1954.
(Collection: Jørgen Meldgaard, Copenhagen)

75 **Tupilak.** A dangerous spirit who haunts the ice and brings
disaster to hunters and misfortune to anyone who meets him.
Wood. From Angmagssalik, Greenland, late 19th–early 20th
century. (Danish National Museum, Copenhagen)

65

they were in the midst of activities which had not even entered their dreams. It is to the credit of their way of life that they were able to accept, as a natural event, the intrusion of a technological world in advance of that known in many civilised countries. They were food providers to the base, and then labourers. Many became skilled technicians, obtaining work of sufficiently good standing to enable them to purchase housing and packaged foods for the support of their families. The cultural revolution was thrust upon the Polar Eskimos in a few years instead of a few generations. For the carvers there was a new market, but really it was of small importance, especially since the Polar Eskimos had previously led so hard a life that there was little time for any experiment in the finer aspects of art. Carvings were made but they were simple and strong rather than elegant; perhaps one could describe them as nearer to the ancient Dorset art than the developed Thule style which was ancestral to modern Eskimo art.

On the western side of the Eskimo world, the progress was not unlike that on the east. However, the growth of an artistic culture had an earlier beginning because of trade contacts. The Siberian Eskimos have become citizens of the U.S.S.R. and, being in direct contact with the state through their local councils and co-operatives, they have been able to form part of the cultural life of the country without giving up their basic subsistence activities. Education and schooling had been among them for a long time, and they were fully ready to enter the modern world. The change for them has also been great but not total.

The purchase of Alaska from Russia altered the balance of contact for the Aleuts. More missionaries came, and gradually, as policy towards native peoples became more enlightened, the Aleuts found themselves provided with schools and teachers. Their relationship to the fishing industries was of great importance and has brought them into the world of trade. American fishery companies have been in close contact with the Aleuts and the result has been an improvement in their standard of living. There was some attempt to establish reservations to protect the native people on some of the islands, but most of the Aleuts have been able to work on equal terms with the other settlers in their islands. The old ways have been disappearing ever more rapidly, and the ancient works of art are as much fascinating curiosities to the modern Aleut as to the Americans. In the process of acculturation, the Aleuts have made some very attractive models of their skin boats with crews and full equipment, and a number of ivory carvings of scenes of everyday life in ivory of quite astonishing whiteness. However, this has developed more as a curio market than an entry to the realms of fine art.

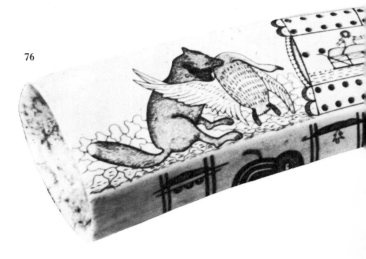

76

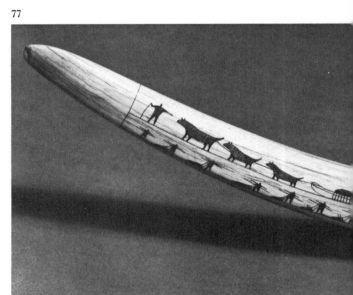

77

We have had to look at the Aleuts as separate from the Eskimos of Alaska because of the linguistic division and the differences which their all the year round sea fishing activities have highlighted.

The contacts of the Alaskan Eskimos among European explorers and sailors gave them some idea of the larger world outside, and they learned to make very good engravings on ivory which often went beyond the usual limits of scrimshaw work. However, the main effect of the contact was not to produce art, but fish and skins. Some people served with the whalers on ships, others came to trading posts, bringing supplies of dried fish and meat to trade for the desirable things of the white man. They needed guns, knives, and canvas most of all. It was all very wonderful that these things from the foreigners helped them to catch more game, and to hunt successfully. The hunters gradually learned that the arctic mammals were not only important from the Eskimo point of view for food and clothing but that

66

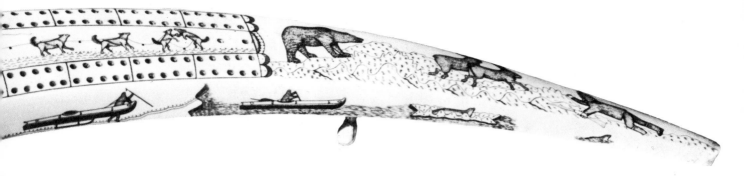

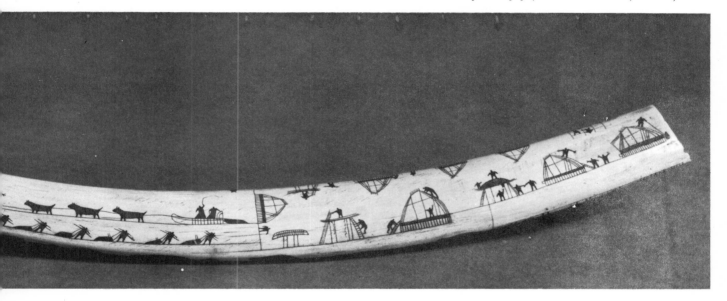

**76 Cribbage board** with realistic engravings. The Eskimos learned to make cribbage boards from contacts with whalers in the mid 19th century and the gold rushes stimulated the sale of ivory carving. The finest cribbage boards were those made around the turn of the century. From the Nome area, Alaska, about 1905. (University of Alaska Museum, College, Alaska)

**77 Walrus tusk** engraved with hunting and housebuilding scenes. From Alaska. Acquired 1909. (Horniman Museum, London)

trade in furs could bring in more useful goods. Before the 1890s, most Siberian Eskimos had learned the use of traps and lines of snares. They had entered into the fur trade without thinking of the scarcities which would ensue a generation ahead.

They did not realise either that now a new people laid claim to their land. The Americans were now feeling a responsibility towards the native peoples of their lands and gradually encouraged the spread of knowledge even if it was given only through mission schools.

Then came catastrophe. Gold was discovered in the Yukon. The gold rush brought in great numbers of rough settlers, miners, business people, saloons and food shops. The Eskimos met the white man on bad terms and found more misery than profit from the trade in skin clothing and in women. Eventually the gold rush petered out. Ruined towns survived here and there, and stretches of unused road cut into the hills. Some whites lived in the settlements around the coast. There were many young people who were neither white nor Eskimo, and there arose a good deal of racial intolerance. However, many of the whites were interested in the Eskimos and some continued to live as pioneers in the lonely north where they really tried to help the local people on the path to a more adequate life.

As time went on the government took an increasing interest in Eskimo education. Hundreds of girls and boys learned to read and write in English. They also spent time in drawing. Half the school time was wisely spent in teaching Eskimo crafts so that when the children grew up they would not be totally out of touch with the life of their people. They were subjected to all manner of aptitude and intelligence tests in which they tended to achieve higher marks early on and then gradually declined to a level below that of the local white children as they grew older. Of course the white children came from homes with a totally different outlook.

The educational programme was urgent because of the development of trading posts and fish canneries along the rich Alaskan west coast. There were jobs to be filled, community relations to be encouraged and a whole group of tribespeople to be gradually integrated into the ways of the civilised Americans. Alaska without gold was still a rich country, and the canneries became famous all over the world. Many Eskimos found useful employment in the new industry. Those who were free remained as trappers with a bias towards hunting for basic family subsistence. But more time was available and more new ideas were circulating.

Missionaries of many sects worked among the Eskimos, usually helpfully. However, the gradual change to Christianity led to emphasis on the nuclear family, and the old communal houses in which the young men found shelter and all the people met for dances and traditional story telling gradually fell out of use. Even the traditional folk tales of the Eskimos began to assimilate other themes from the white teachers. There was also a small but steady trade down the west coast in Eskimo curios; ivory and soapstone carvings, dolls, and models of Eskimo life which had a market value. This was never a deliberate policy; it simply developed as a by-product of the culture contact between the two peoples.

By 1930 education had progressed; some Eskimos had even gone to college and travelled by aeroplane. But world events were to cause further changes, later on. The world balance of power demanded a defence line of radar stations right across the arctic. In Alaska as well as in Greenland the Eskimos found that they could become skilled technicians and enjoy a higher social status. Alaska became a fully fledged State, and with this change there was a heightened interest in the welfare of the natives. The most recent great change in Alaska has been the discovery of an enormously rich oil-field near the shores of the Arctic Ocean. Again Eskimos have been engaged as workers and professional hunters. So they have found a higher standard of living, though in a manner hardly dreamed of by their parents. However, the construction of pipe lines has interfered with the migrations of the caribou, and special arrangements have had to be made to help those Eskimo groups whose livelihood is threatened. All in all we may say that the Alaskan Eskimos were the most advanced people of their race in old times, and that the change of climate as well as the greater cultural exchanges have kept them in the forefront of development.

The story of the Eskimos living in the Canadian arctic is far more complicated. There were fewer of them, some 15,000 out of a total Eskimo population of about 80,000. In culture they differed widely from one another because of the variety of natural resources and also because of the great distances between one group and another. The arctic explorers had found them a cheerful people who were always ready to welcome visitors, and who faced life on the edge of disaster with patience and a spirit of hopefulness. They relied a great deal on their belief that the great mother spirit living under the sea would send her children, the seals and whales, to help her human protégés. The spirits in the air were also ever around. When disaster struck, people died, sometimes a whole community. That was natural, and was perhaps aided by evil magic. But for the good hunter and the well-organised family, life brought enough and left a little time over for enjoyment and social life within the small communities of a few dozen people. Sometimes, though rarely, they met strangers and that was the occasion for an orgy of happiness and friendship. Food, companionship, sex, and a general sense of cosiness made life totally enjoyable on such occasions. But everybody knew well enough that the food animals were limited and that the visitors would return to their own group when the time came, in order to spare the food supplies of their hosts. The pleasant days of summer passed, and with happy memories and tales to tell by the winter blubber lamps they returned, hunting as they went.

The Eskimos who were most remote from the normal way of life were the Caribou Eskimos of Keewatin. These people lived like late Palaeolithic hunters of the last Ice Age. Fortunately for our understanding they were sought out in the early part of the twentieth century by Canadian ethnologists who have given us a very full series of studies of their way of life. It was fortunate also for the Caribou Eskimos because they were now known to the Canadian authorities, and visited occasionally.

Disaster struck the Caribou Eskimos in the middle of the century; epidemics of respiratory diseases broke out and took a terrible toll, and nearly a third of their small population died. Then a scarcity of caribou developed. Disease had also struck the herds, and there had also been dispersal through hunting, so smaller groups passed over the usual migration routes. The Canadian authorities had established some welfare help but the Eskimos with typical self reliance failed to send word of the extreme economic difficulties which threatened them. They tried fishing through the ice with little effect. The bands tried to keep apart on the good old tradition of allowing each as much hunting ground as possible. But one group suffered a greater disaster. An accidental fire in a store hut burned it down, killed two of the men working at it, and caused the death by starvation of seventeen other isolated people. That single disaster nearly

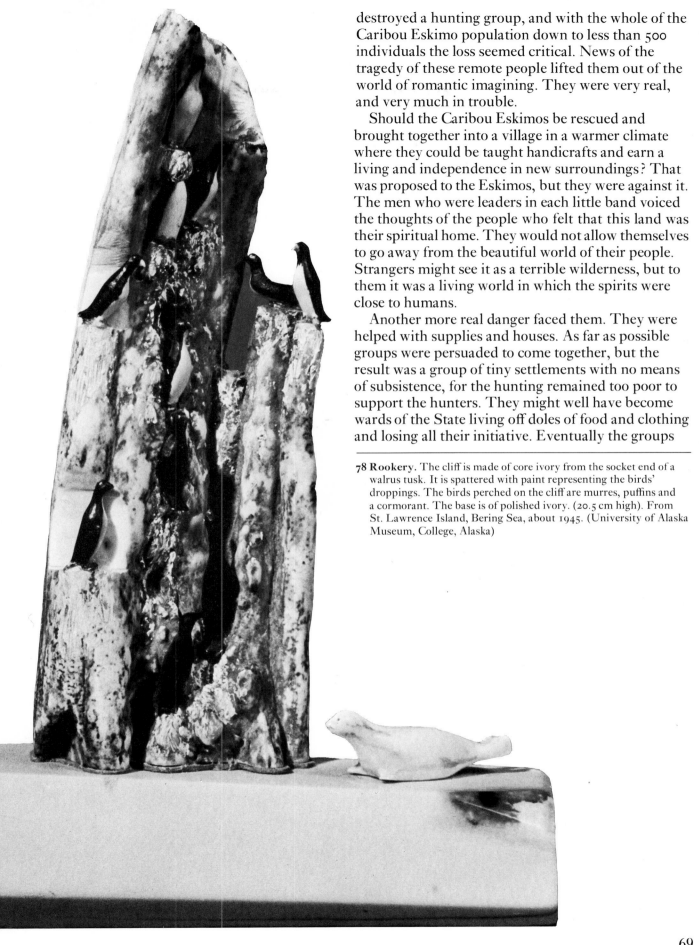

destroyed a hunting group, and with the whole of the Caribou Eskimo population down to less than 500 individuals the loss seemed critical. News of the tragedy of these remote people lifted them out of the world of romantic imagining. They were very real, and very much in trouble.

Should the Caribou Eskimos be rescued and brought together into a village in a warmer climate where they could be taught handicrafts and earn a living and independence in new surroundings? That was proposed to the Eskimos, but they were against it. The men who were leaders in each little band voiced the thoughts of the people who felt that this land was their spiritual home. They would not allow themselves to go away from the beautiful world of their people. Strangers might see it as a terrible wilderness, but to them it was a living world in which the spirits were close to humans.

Another more real danger faced them. They were helped with supplies and houses. As far as possible groups were persuaded to come together, but the result was a group of tiny settlements with no means of subsistence, for the hunting remained too poor to support the hunters. They might well have become wards of the State living off doles of food and clothing and losing all their initiative. Eventually the groups

**78 Rookery.** The cliff is made of core ivory from the socket end of a walrus tusk. It is spattered with paint representing the birds' droppings. The birds perched on the cliff are murres, puffins and a cormorant. The base is of polished ivory. (20.5 cm high). From St. Lawrence Island, Bering Sea, about 1945. (University of Alaska Museum, College, Alaska)

were persuaded to settle at least for the winter at Baker Lake, where there would be shelter and a certainty of food during the harsh days. It was in the Baker Lake settlement that the new impact of a profitable art market came to the Caribou Eskimos.

Art came suddenly in 1960, when Mrs Edith Dodds, wife of a Northern Service Officer stationed among them at Baker Lake, thought that it would be a helpful thing to start a handicrafts class for the Eskimo women in the lonely and disheartened group. After a while she met James Houston who had stimulated Eskimo art as a source of income among the people of Cape Dorset on Baffin Island. He was interested and was given two drawings by one of the Eskimo women, a widow named Una. They were so good that they were sent to go with an exhibition of Cape Dorset art.

In the next year, the Dodds were sent to a station in Ungava Bay where they met Bill Larmour, a Crafts Development Officer from Ottawa. He was persuaded to visit the lonely people at Baker Lake. He found a beautiful carving had been made by an old hunter, Angosaglo, and that decided his line. A wooden house was erected as a centre to which children and grown ups were always welcome. They saw him carving and were delighted. Some went home and spread the news through their families. Then a young man from the group returned to them more healthy than he had been, but still terribly crippled through poliomyelitis. The people were grateful that Willie, a junior kinsman of Angosaglo, was kindly treated and brought to live among them. To show their pleasure they brought carvings they had made. A council of the people met, and it was again old Angosaglo who suggested that he and some of the other elders should show the youngsters how carvings in ivory and stone were made in the old days.

The great interest aroused led to a steadily advancing style of art. Things went so well that a permanently resident Arts Officer was appointed, Gabriel Gély, who taught people how to draw, to carve in ivory and to make jewellery from the translucent horn of caribou hooves. They were encouraged to work at their own speed and depict their own subjects. The work was a tremendous success. It sold and brought cash which could be exchanged for goods. Eskimos who would have starved now earned up to a hundred dollars a month. Artists developed among the craftsmen, and eventually some fine sculpture and prints were produced which fetched good prices. The

79 **Two whale bone masks.** Possibly Alaskan, early 20th century. (Gimpel Collection)

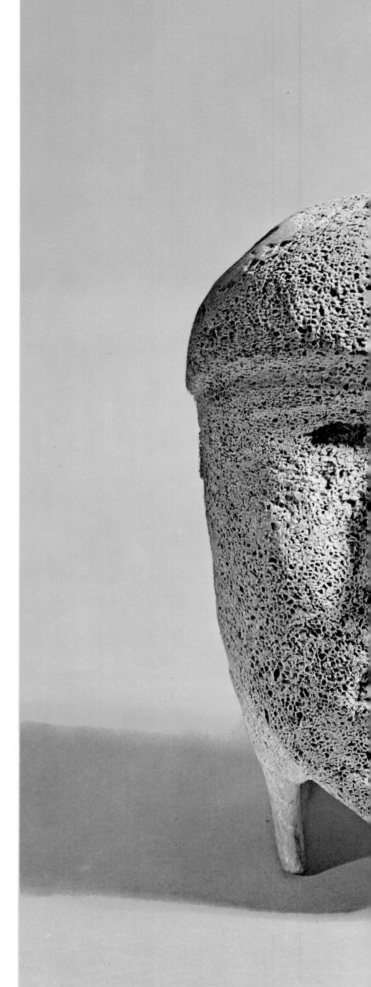

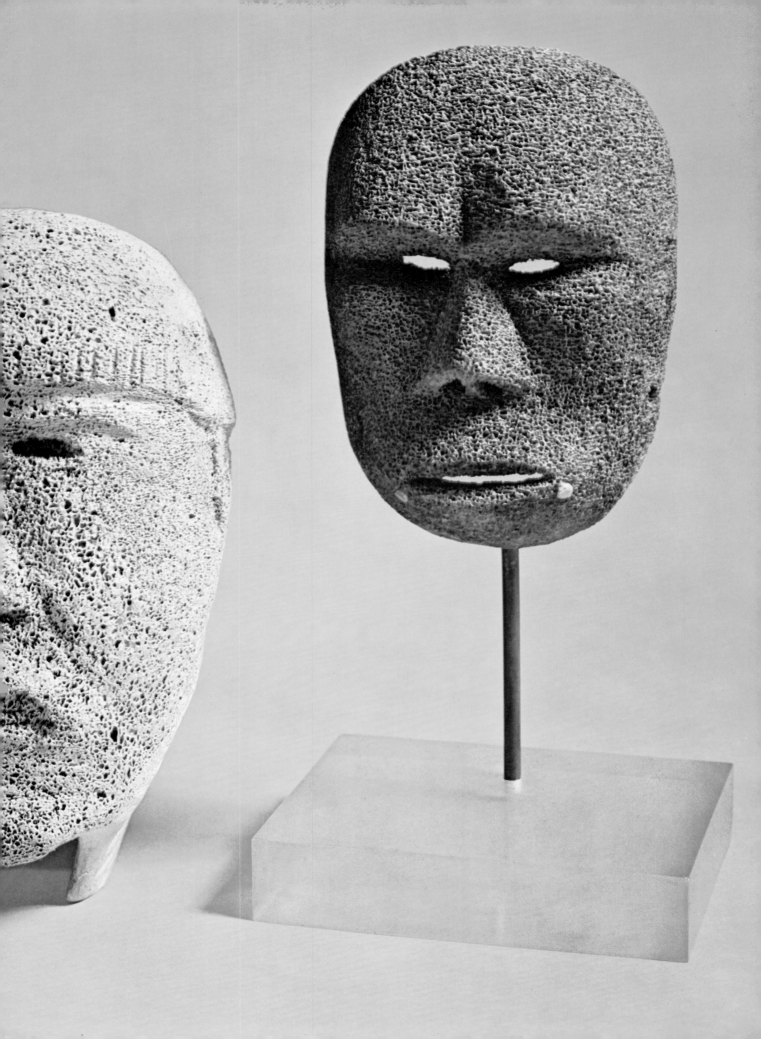

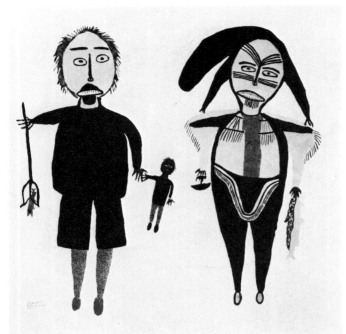

Caribou Eskimos had survived, and had escaped the heart-searching miseries of pauperism by producing work of their own which could help them earn a living in the modern world. It was all to the good that they went naturally to depict the living creatures of their world, including, of course, the caribou. So in modern times a tribe of hunters who had been lost in the terrible confusions of a changing world have found a new footing which promises to be a stepping off point to a more secure future.

We have mentioned the artists of Baffin Island. They have an important place in the story of modern Eskimo art. They have been people of active interests. For much more than a century they have been in contact with Europeans. Their original life-style has gradually changed, mostly under the influence of exchange of goods with the visiting whaler crews. There was rarely any shortage of food among them, and their initiative was shown by their journey in the 1860s to visit the Polar Eskimos when

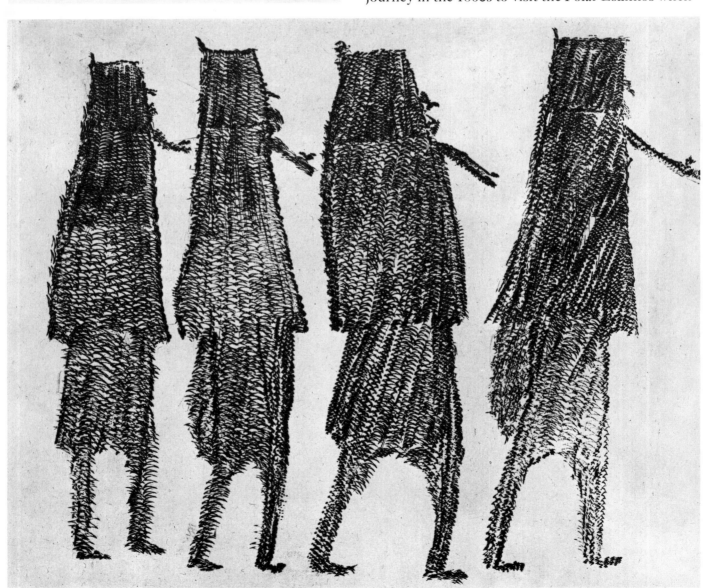

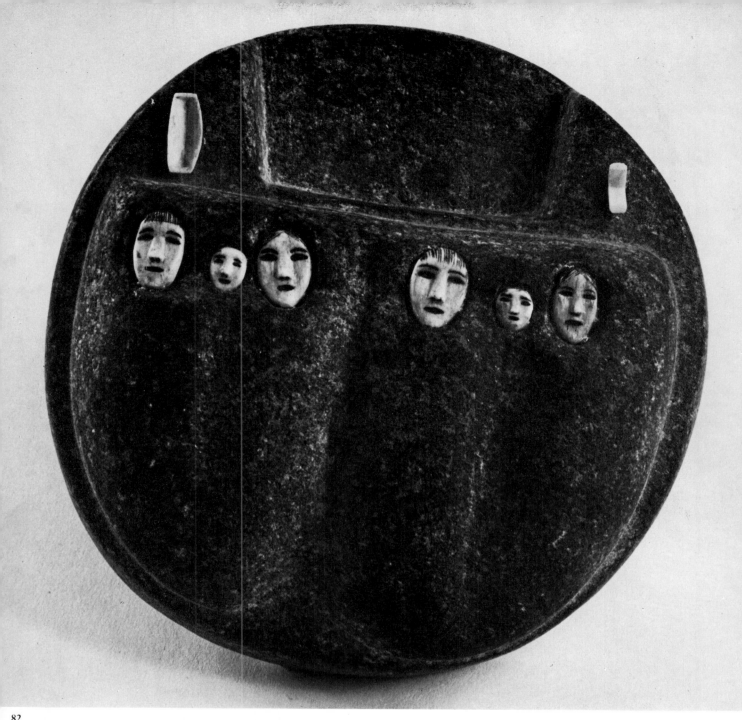

82

they showed them traditions which had been lost in the centuries under the arctic night.

The impulse to a closer unity of the people came from the establishment of a school in about 1950. It was comparatively easy for the Canadian Government to plan for Eskimo development in this area. There was already good contact through the Hudson's Bay Company trading post at Cape Dorset which was set up in 1918. The new school among an Eskimo population already mostly Christian and used to meeting together caused some migration from outlying settlements because the Eskimo family is very closely integrated and people felt it was good to move near to the children. The result was a concentration of people around Cape Dorset in the

extreme south of the island. The community was already well off by Eskimo standards and their economy was based on the great wealth of the region in fur-bearing animals and fishing. The burden of the change fell mostly on the men who travelled further from home to reach the hunting and trapping areas. Trade was well established, and the Eskimos had a council which threw up an active leader who was

80 **Family** by Angosaglo and Tatunak and Toweener. Baker Lake, N.W.T., 1972.
81 **Four women** by Parr. Copper engraving (25 × 30 cm). Cape Dorset, N.W.T., 1963.
82 **Two sleeping families** by Sheeookjuk. A moss wick lamp stands beside them. Grey stone and ivory (5 × 16 × 16 cm). Cape Dorset, N.W.T., 1953. (Canadian Guild of Crafts – Quebec Branch, Montreal)

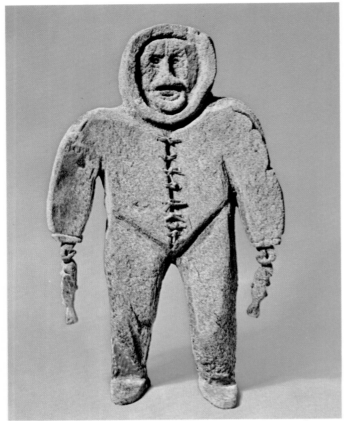

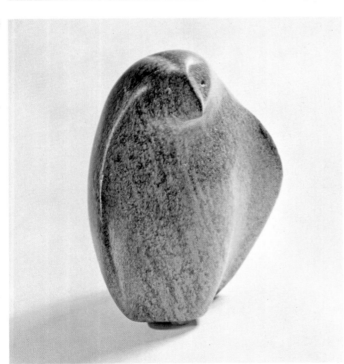

83 **Man carrying two fish** by Peterosee Anigliak. Whale bone
(45 × 26 × 10.5 cm). Pangnirtung, N.W.T., about 1966.
(Collection: Macmillan–Bloedel Limited, Vancouver, B.C.)

84 **Owl** by Qirluaq. Notable for the abstraction of the form.
Grey-green mottled stone (15.5 × 12.5 × 7.3 cm). Repulse Bay,
N.W.T., about 1968. (Collection: W. Eccles, Toronto)

85 **Bear on ice** by Manno. The bear looks at his reflection in the
melting ice. Light grey-green stone (9 × 17 × 8.5 cm). Cape Dorset,
N.W.T., 1964. (Collection: W. Eccles, Toronto)

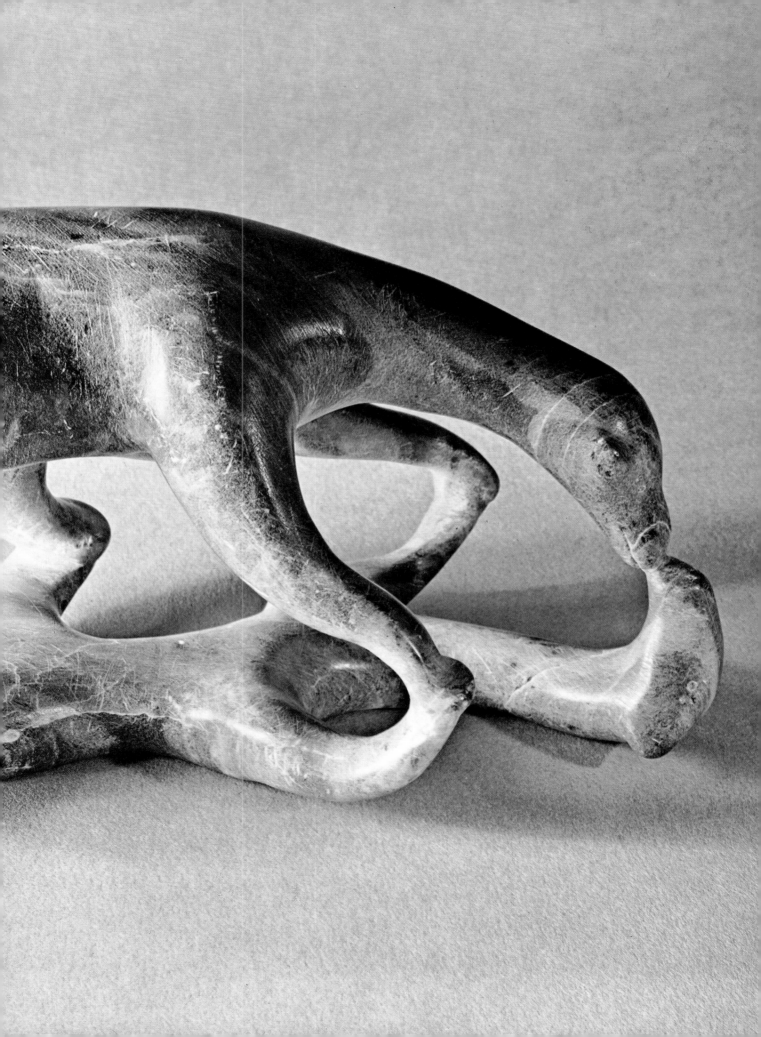

**86 Resting caribou** by Oshooweetook 'B'. Green stone and bone (37 × 44 × 29 cm). Cape Dorset, N.W.T., 1970. (National Museum of Man, Ottawa)

**87 Untitled stone cut** by Parr. (76.5 × 65 cm). Probably representing geese or swans swimming. Cape Dorset, N.W.T., 1961.

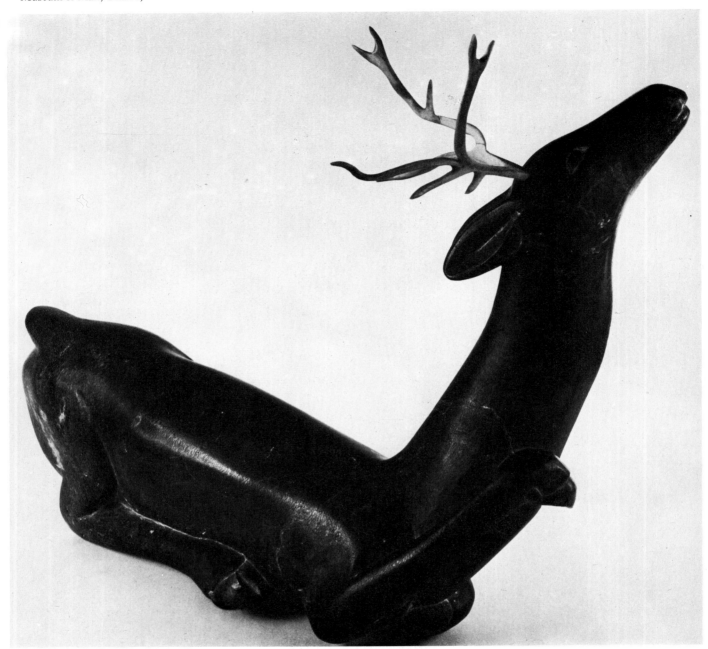

instrumental in arranging for a church to be built. Thus when the art movement began to get under way there was a nucleus of a small township at Cape Dorset, almost as entirely assimilated into a new mixed culture as the little towns in Greenland.

In 1951 the Canadian Government sent James Houston to Cape Dorset with the avowed purpose of encouraging the local population to produce carvings and paintings for trade. There was considerable interest and several artists were happy at the chance of turning their abilities into an additional means of providing for their families. In this case there was no abandonment of Eskimo life since trapping and

hunting were so important economically that when the hunting seasons arrived the artists simply went away to the icefields. The women, however, had much less work to do. Improved economics meant that they had a cash income and that in turn fitted out the families in woollen clothes imported for use during the warmer months of the year. The superior ancient style of fur clothing was retained for use during the colder weather. Thus women of Cape Dorset have had leisure to employ their skills in making art of importance. Some of them became the makers of the first arctic lithographic prints from stone. They had learned from the white teachers and

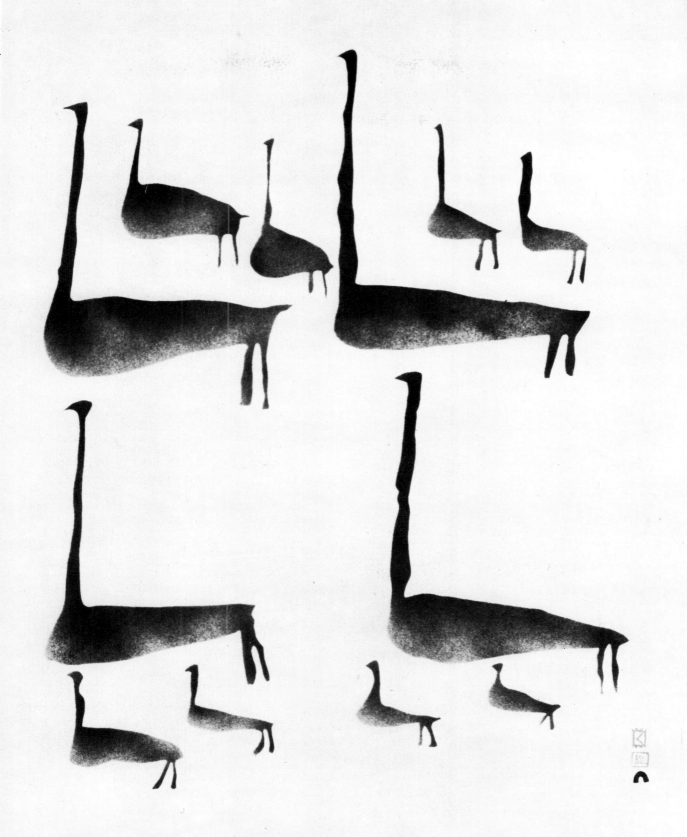

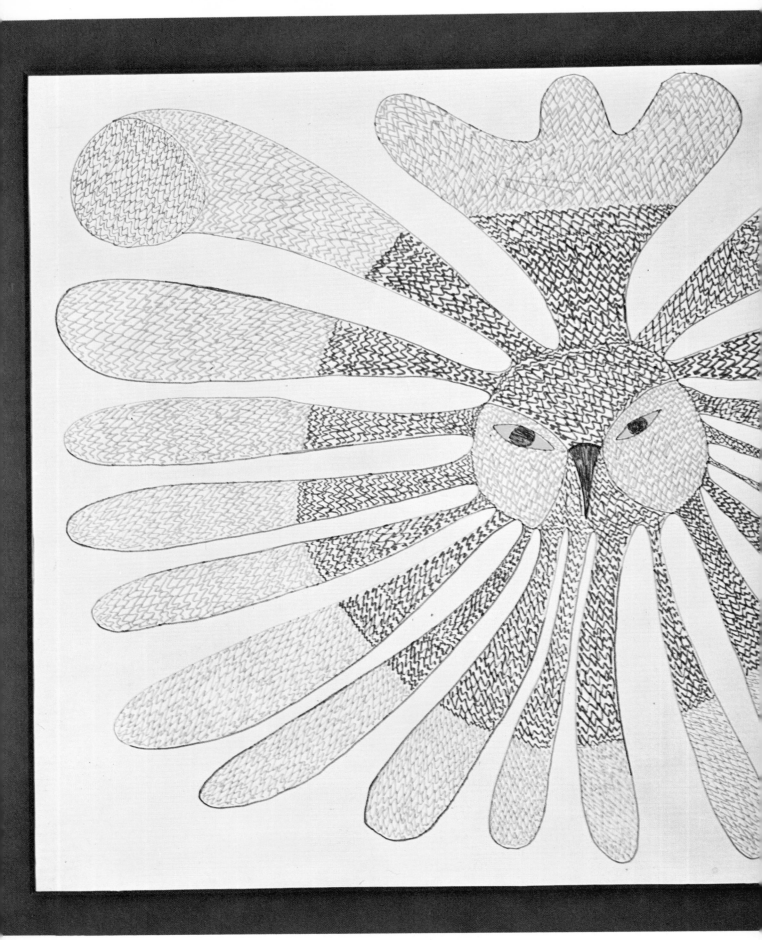

acquired a technique, but their subjects were the life of their own people in the setting of the living world of arctic Canada. It was with this background of artistic development among an advanced Eskimo community that James Houston went to the Caribou Eskimos and found them similarly responsive.

The art of Cape Dorset has importance for all of the sixty or seventy families permanently settled there. It is part of a general economic development of trade combined with cottage industry. The Eskimos have shown great acumen in organising this new life. They were given some state encouragement and have formed their own West Baffin Eskimo Co-operative, which supplied not only art but also beautiful skin garments and ivory and stone jewellery. Eventually they have been able to establish a shop of their own in friendly rivalry with the Hudson's Bay Company.

Today the Eskimos of Cape Dorset live in framed wooden houses with double walls, dry and easily heated in winter. In the summer they hunt from canvas tents. In many households the dog sledge has been replaced by the petrol-driven skidoo. Electricity is available, but the climate has prevented the installation of piped water. People have radios, watch television and provide enough material for a monthly aeroplane service to be maintained. A new form of Eskimo culture is developing in which the people preserve their identity while making use of the advantages, particularly in trade, which come from the mechanised civilisation of the modern world. Further steps will be taken, probably in the direction of animal farming over the vast spaces available on Baffin Island.

The development of arts reached the lonely Copper Eskimos on Victoria Island and around the mouth of the Coppermine River rather late. Like the other peoples of the arctic shores they had a long contact with the sailors on the whaling ships. They had met ethnologists who were interested in their use of raw copper for tools. They were much admired for their skill in blending furs for dress. But the hard fact was that apart from the losses from respiratory illnesses they were finding that the returns from hunting were continually decreasing and that it was desirable to move nearer to the settlement of Holman on the west coast of Victoria Island. Kalvak, an Eskimo widow in her sixties, when asked to make a skin parka for the Oblate missionary, Father Tardy, picked up a pencil from his desk and made a rough drawing of the design. At many later meetings Kalvak gave long accounts of the folklore of the Copper Eskimos. She had this knowledge through her husband who had

88 **Owl** by Kenojuak. Drawing. Cape Dorset, N.W.T., mid 20th century. (Gimpel Collection)

79

been a famous and powerful angakoq. As she told the stories she developed a talent for graphic art, making illustrations, sometimes on paper and sometimes as cut-outs in skin. Her enthusiasm brought four other artists in the Holman settlement to the missionary. They all produced interesting work of gradually increasing freedom, and in their own style. They had no direct art education at all but expressed their ideas directly in stark black on white, often in cut-out silhouettes.

It was as late as 1961 that Father Tardy saw Eskimo art, a Cape Dorset print hanging in the hospital at Yellowknife. He enquired about the process and when he returned to Holman he got two or three of the older boys to try out screen prints from blocks made of sealskin. The work was not too interesting, mostly because the boys needed to spend as much time as possible hunting. But during the slack season of winter, some of the older hunters proved more willing to spend time making blocks and printing from them. It was important that two of the first batch of prints sold at five dollars apiece. However there was little further success until in 1963 when the Department of Northern Affairs and National Resources sent out Barry Comber of the Toronto College of Art to guide the Holman artists. They were somewhat reluctant to start again, but enjoyed being given freedom to draw whatever they wished. Then they began to sell again. In 1964 a local deposit of fine-grained limestone was found. The skin blocks were discarded and lithographic inks were used on the stone enabling editions of up to twenty copies to be produced. The new process was very successful, and much more colour was possible in the products. Here Kalvak came in again. Unable to handle the limestone blocks which were too heavy for her, she produced designs on paper which were transferred to stone by the other members of the group. In 1965 a series of prints was sent to the Eskimo Art Committee who approved most of them for sale, and at an exhibition in St. John, New Brunswick, the Holman prints sold out. Once more art had become a source of added income to a remote Eskimo group. An especially interesting feature of Eskimo lithographs is the emphasis on soft and deep colours, particularly blue and red. This is very close to the use of ink colouring in bone engravings from Siberian Eskimos, and it may be that the choice reflects facets of arctic life and belongs particularly to Eskimo tradition.

The most easterly area for the production of Eskimo art is at Killinek (Cape Chidley), where Ungava Bay meets the Torngak Mountains beside the Davis Strait. The region was rich in sea foods, but the Eskimo settlement there was few in numbers; in 1952 there were only thirty-two individuals. Their livelihood was restricted because their best boat could not be repaired and there were not enough young men among them to undertake the hard work of the food quest. They were given government assistance and a fishery and canning station were established. School was attended, and the community prospered so that outlying groups of hunters came in. Among the new work prepared were engravings, stone sculpture from the many beautiful stones obtainable on the rocky coast, and ivory carving. In the slowly growing community where shortage of human power almost brought the settlement to extinction, there has been an acceptance of help and a deliberate choice of a new way of living. In this the production of art has played a minor part, but it has had a good effect on the personal lives of the people, who have discovered the pleasures of individual skills once again. Of course in an area of rich sea resources the artists remain a minority, but they prove that the Eskimo is by nature able to express life in terms of graphic art. And works of art form part of the material traded through the local Eskimo co-operative.

The development of modern art among the Eskimo people dates apparently from about 1948 when James Houston brought a steatite carving from an artist at Povungnituk on the coast of Hudson Bay. In this region the local people had worked in the beautiful local stones of serpentine and steatite, easy to work and giving beautiful surfaces if finished with care. The art had, even at that early phase, become accepted by the local people as worthwhile. It is from this contact that the steady growth of Canadian Government help to the artists in Eskimo communities can be dated. The idea has spread. The white teachers have in general avoided teaching more than technique, and the styles and the meanings of the new art remain truly Eskimo. They differ widely among themselves, each individual having a style which is usually reflected by the local community. But each community has its own ways and is not often influenced by the art of other Eskimo groups.

However, the idea of art being distinct from everyday craftsmanship is a new one to the Eskimos. It has been hard to abandon the old ways, particularly since the break-down of the old way of living has been due to the disappearance of caribou and whale as well as many other animals. Hardship and hunger have been hard spurs to change. The love of children and family unity have been the silken cords which have drawn the Eskimos into a new life. Over the whole arctic the numbers of Eskimos are steadily increasing again, while the number of settlements has decreased. They are able to live in greater contact with their fellows, which after all is a satisfaction for the Eskimo genius for friendship. In these

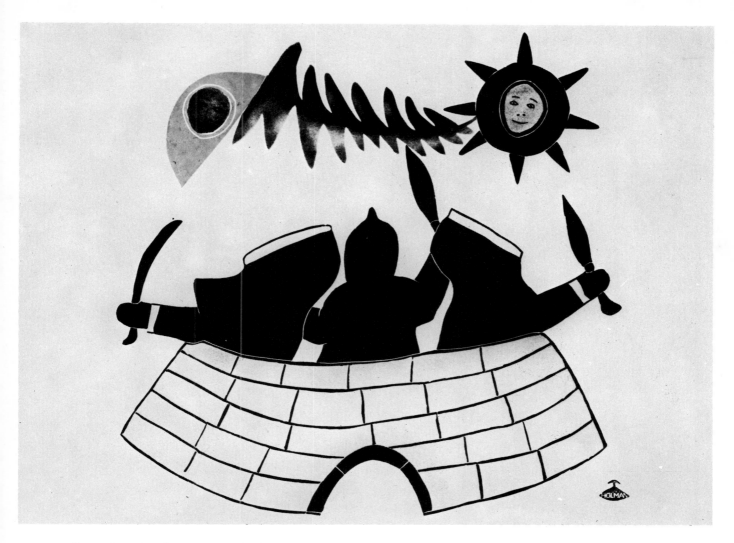

surroundings there has been a practical attempt
by the Eskimos to assimilate in their own way.
They have been fortunate in finding friends among
administrators and teachers who did not impose white
standards upon them without consultation. For the
white man, too, the world has changed and the ideas
of a century ago have been broken down, so that
Eskimos are now seen as adult and intelligent people
and not as perpetual childish wards in need of care
and assistance.

On the extreme boundaries of the Eskimos, the
people are full citizens of the countries which have
control of their geographical regions. The U.S.S.R.
has assimilated the few Siberian Eskimos of the
Bering Strait. Denmark has given full and free
citizenship to the Greenlanders. The U.S.A. and
Canada still have a protective organisation to look
after Eskimo affairs, but in practice the Eskimos have
a share in discussing and organising future activities.
This freedom and democratisation is steadily growing.
With it an art market has developed, in a loosely
organised way in Denmark and the U.S.A., and in a
much more closely organised fashion in Canada.
But in all areas Eskimo co-operative trading centres

are organised and active. They seem to be the natural
way for the Eskimos to organise themselves. They
have always been at once interdependent within the
community though self-reliant as individuals. They
have rejected dictation even within the village, but
have listened with respect to the wise elders of the
community. So the primitive Eskimo codes of social
life are still powerful forces in the modern world.

The production is not a matter of group working
on a time chain, but of free creation and free trading
through the local organisation. For Eskimo art a new
world is opening. But how does it look to us on the
receiving end of the market?

89 **The land of ice and snow** by Kalvak. The Eskimo family are
building their igloo while the sun lady and the moon man are still
visible in the sky. Print. Holman, N.W.T., 1970.

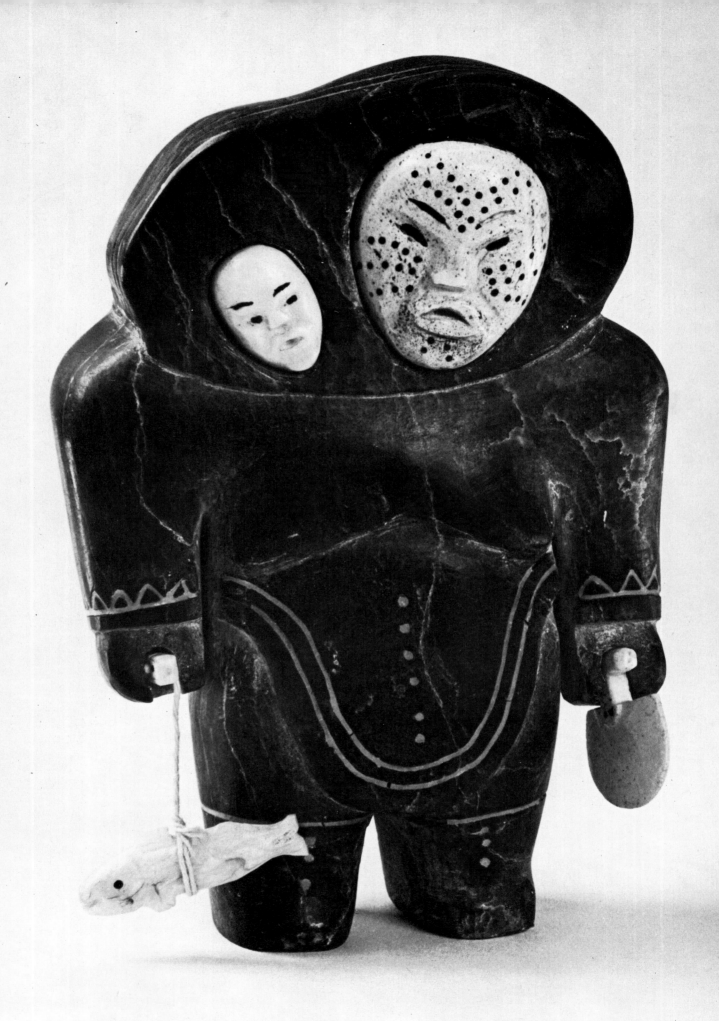

# Eskimo Art and Artists

When people come across traditional Eskimo art in museums there is usually a friendly fascination. The little figures of animals and people polished in bone and ivory have a great charm about them. They reflect a peaceful life in a world of hardship and beauty. Emotional responses towards the little animals are conditioned by the type of our civilisation; they are not usually seen as the quarries of the hunter but as the pets of childhood. Even the terrible polar bear becomes a cuddly creature seen at the zoo. The tendency to show the human figure naked and in a static verticality does include some deep level linkage with sex, but overt sexuality is rare, not because Eskimo artists lacked erotic interest, but because they had no need to stress it in a life which was natural and fulfilling. Our conscious reaction to Eskimo sculpture is an appreciation of the surface forms. There is an element of pleasure in handling the ivories. These carvings were meant to be handled, oiled and fondled. To touch them is to enjoy a tactile pleasure important to the understanding of their meaning. Whether we can judge their artistic quality separately from their own cultural setting is not in question. The majority of works, especially of the Thule phase of Eskimo culture, can be immediately understood as works of art. Questions of proportion, rhythmic structure, and unity of appearance from all angles are quite proper in appreciating them. They can be compared with small animal forms of Western cultures such as Roman or Renaissance bronzes. They have a different degree of realism largely because of the limitation of means available to the old time Eskimos, but they stand the comparison well, and to many people the Eskimo works are superior because of the artist's natural understanding of animal forms which is distinct from the intellectual understanding of the European artist. Therein lies the importance of small Eskimo sculpture: its simplicity of approach.

How can we judge Eskimo art through the time scale which is only recently becoming apparent? We have seen so many different styles, from the art of the earliest peoples of Alaska and Siberia who decorated roughly shaped ivory carvings with delicate linear patterns, to the vigorous and magical sculptures of the Dorset culture and the more delicate and elegant products of the Thule culture. Critics differ sharply in their assessment of the aesthetic quality of Eskimo art, yet it is a subjective criticism because we have little reliable knowledge of the meaning and purpose of many of the pieces. All we know is that since early times there was a great emphasis on the angakoq and his religious trance phenomena. The famous ivory mask-frames worn around the face of an angakoq belong to the early Ipiutak people who lived near Point Hope in Alaska. Dorset culture artists produced sculptures of seals and polar bears; the bear sometimes had human limbs and we are sure it is an angakoq in disguise. Likewise the Igloolik wooden masks with characteristic flaring nostrils, and the comb with the demon face all had a magical significance. It is not until contact occurred with outsiders that Eskimo art developed the features of sailor-inspired scrimshaw.

We also know that many items of everyday use were carved or decorated with good luck symbols. Such charms might be made by any member of the community, not necessarily the angakoq. They were, however, magical and their intention was often successful in their position of a psychological support to the hunter. The making of the carving put the artist in contact with the soul of the animal, or perhaps one should say 'idea' in the Greek sense. When using the arrow the marksman looked for success. There was less hesitation and doubt about the shot, and so it was in fact likely to be more successful. Naturally such magic works best for people who are living in the untroubled world of the unconscious mind without the considered need to rationalise every act into a conscious movement for a conscious purpose. It is because of this unthinking production of the old ivory carvings that they so often appeal directly to us. We rationalise, 'this is a bear, that a seal', but somehow that animal seems more attractive than just a representation. It has something of the animal itself. The unconscious mind responds by a kind of reflection of the original idea, not complete of course, because our material culture is so different, but the animal becomes much more of a real experience than

90 **Mother and child with a fish.** Green stone and ivory (17 × 11 × 8 cm). Port Harrison, Quebec, 1954–1955. (Collection: Mr and Mrs John K.B. Robertson, Ottawa)

91 **Swan and duck.** Green stone. From the Canadian arctic, 20th century. (Gimpel Collection)

92 **Bird with wings spread** by Sheeookjuk. Green stone (12 × 24 × 5 cm). Cape Dorset, N.W.T., about 1960. (Collection: Mr and Mrs John K.B. Robertson, Ottawa)

93 **Bear.** Serpentine. From the Canadian arctic, 20th century. (Gimpel Collection)

91

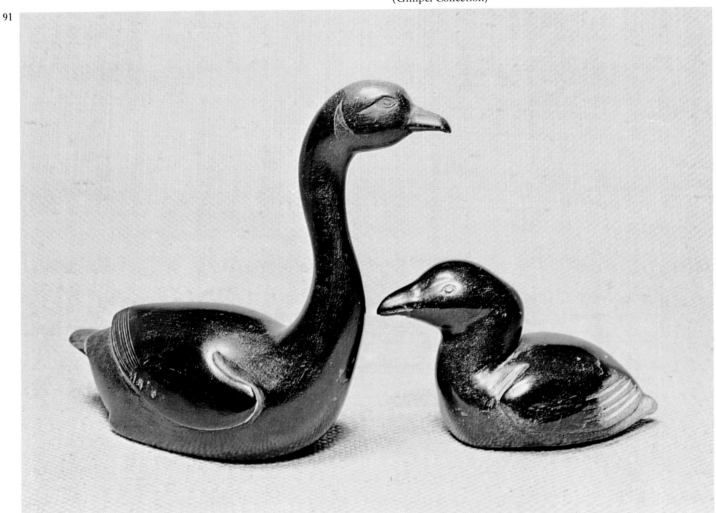

the simple fact of a carved ivory representation would warrant.

Many of the Eskimo works of art of the nineteenth century became known through the sailors on whalers and fishermen from the fleets sailing to Alaska and Greenland. They included many a pleasant trinket, a bunch of carved fish, a carving of a hunter with his dog team, or indeed any other representation of arctic life. Sometimes sailors picked up little gambling sets of miniature birds and mammals. They were charming, and amused the people at home who had no conception of their serious purpose as gambling counters. Naturally, not many of the charms and magical material of the angakoq found their way to the south. They were rather frightening objects, and when the people became Christians they hid or destroyed many of the sacred objects of the old days. Those which reached southern lands were collected by ethnologists, acquired from sympathetic

friendship and payment in kind or cash. Although we shall probably never know the exact traditions behind the prehistoric objects, they form a link with the folklore which is enshrined in modern Eskimo art.

Much of Eskimo art shows an interpretation of folklore in connection with the heavenly bodies. The sun is a beautiful lady with tattooed face, and the moon is an impulsive young hunter. The Pleiades are the hunter and his dogs who chased the white bear up into the sky. The Aurora Borealis is the world of souls who suffered sudden death in this life, who now sometimes come out to play football with a walrus skull across the sky. Whether Eskimo technicians and engineers of the future will laugh at the old fantasy world is unclear, but to judge by what has happened in our own culture, there will always be people who tell the old stories and feel in their hearts that there is an ancient truth preserved in them even though it is expressed in a most unscientific way.

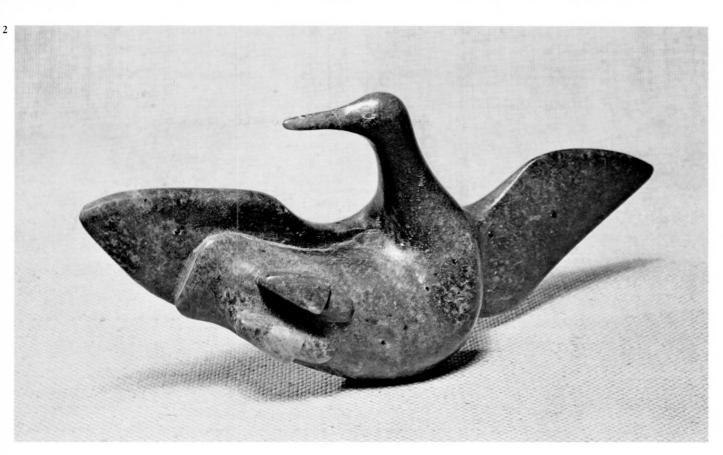

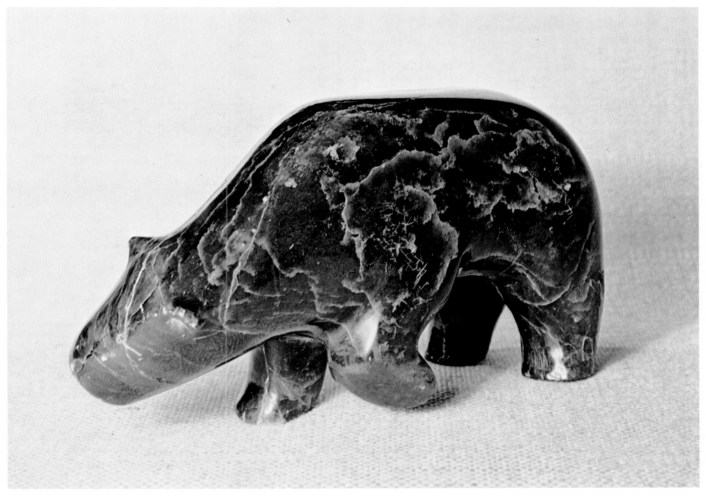

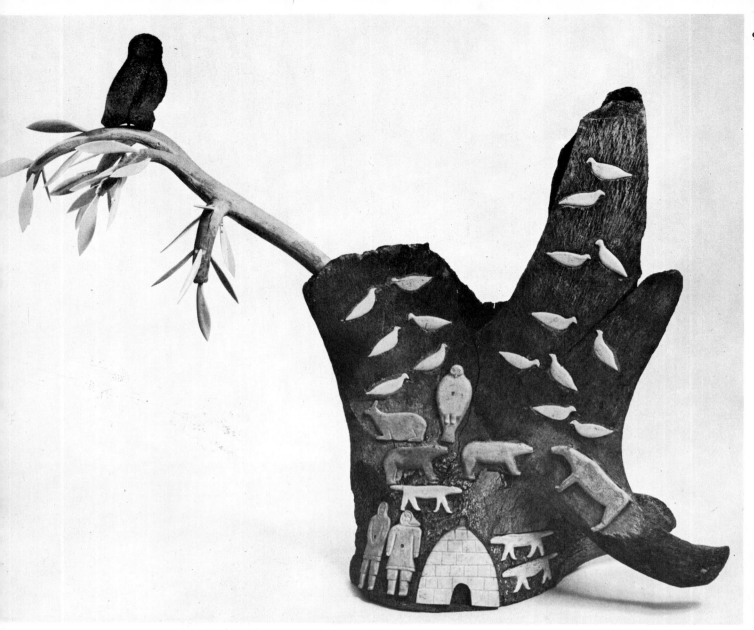

Eskimo folklore includes some quite charming stories which can still have a reference to art. Here is one about a rock by the sea shore. Once upon a time there was a poor woman; she had no relatives and no friends. People gave her scraps of food and bits of skin if she worked for them; sometimes they grew angry with her and abused her. She was unhappy and friendless. One day when she was rowing a umiak she gradually grew more and more tired. So she rowed to the shore and sat on a rock with her head on her hands thinking sadly of the cruelty of people and her own hopeless situation. She wished she could die and that her hard labour and thankless tasks were all finished. Then it came into her mind that it would be lovely to become a rock like the one she was sitting on. Then she would always be resting and see all the sea and sky without any more pain. She wished so strongly that her wish was heard. A crow came cawing down from the sky; he circled around her three times, and

cawed and cawed, and as he cawed she slowly turned into a rock without losing her shape. Then afterwards when the sea hunters went by her rock some of them would make little gifts of needles, blubber or tobacco, and some women passing by in their boat were touched by her sad story and put a beautiful necklace around her neck. But now the sea animals have gone away and so have the Eskimos and the stone woman is once again left all alone.

There are many tales of sadness; perhaps they were told to children so that when they grew up they would be merciful. They belong to the world whence

---

**94 Composition of tree with owl** by Josephee Kakee. Whale bone and ivory (66 × 81 × 26 cm). Pangnirtung, N.W.T., 1968. (National Museum of Man, Ottawa)

**95 The Migration** by Joe Talirunili. Grey stone, bone and skin (33 × 32 × 19 cm). Povungnituk, Quebec, 1964. (Collection: Pat Furneaux, North Augusta, Ontario)

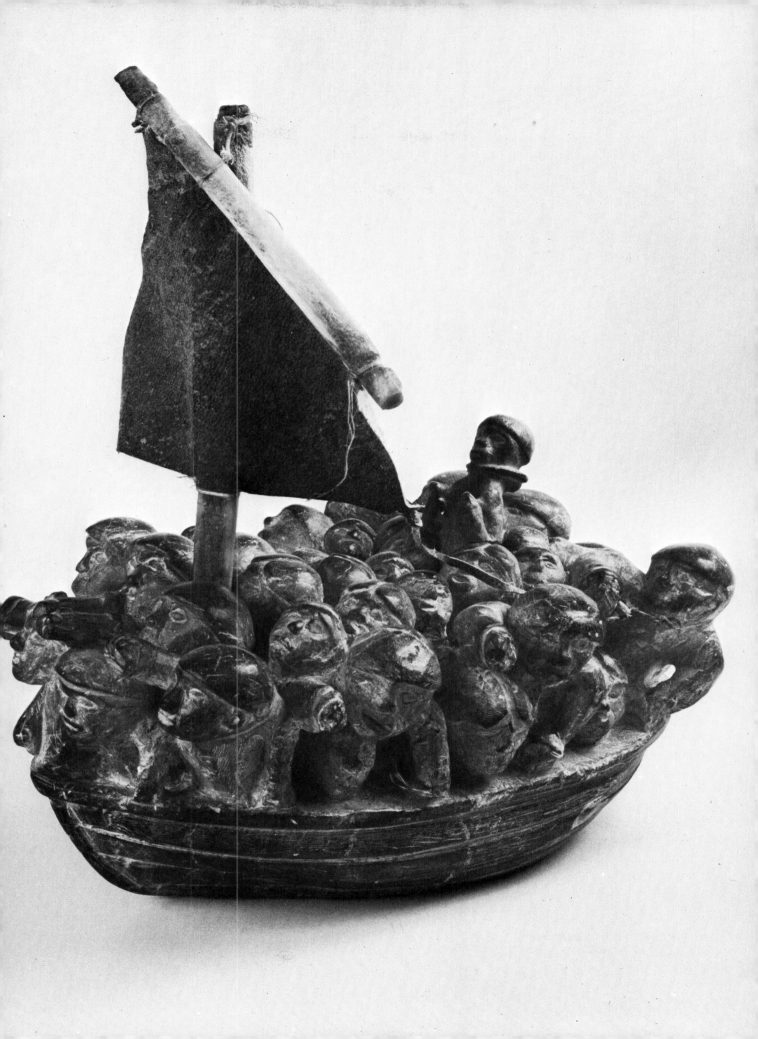

Little Red Riding Hood and Hansel and Gretel came into the European stories. There were also the giants. Not all giants were human either. There was a time long ago when a great shaman was taken by the torngak (a spirit guide and protector) to see a marvel he had always wished to behold. Every year since he was a child he had seen the caribou come from the north and pass south in great herds, crossing rivers and ever seeking their way to some distant goal. 'Where do the caribou go in the winter?' was his constant request to the spirits who came to his séances. Now he was to be shown the way, but first the torngak warned him that he must never tell other people where he had been. He promised, and then the torngak told him the direction in which to seek. He gave the hunter two pairs of magic boots. Then the search went on. For two moons the hunter-shaman walked over the tundra. Patiently he trudged ever forward, until the torngak appeared again. He was told to stop and be silent until sundown. Only one more thing must he do and that was to avoid wishing to kill anything he saw. He vowed to suppress his natural desires as a hunter and so was allowed to remain.

As the sun set the world was bathed in a shimmering light of magic; he moved a little and then saw afar off an enormous house of rocks and moss. It was entered by a huge tunnel before which stood a bull moose with spreading antlers. The animal was so huge that he was terrified, especially when he realised that the mists swirling towards it were vast herds of caribou from all directions. Silently they walked towards the great Master of the Caribou. They walked under his body without touching him and went to find warmth and food and rest in the great house under the earth. When all the caribou were home for the winter the giant lay down and rested, guarding the cave until the time should come when the herds must return northwards with the summer.

Then the torngak came again to the hunter-shaman. He gave him wings and he flew through the mists to find himself back again among the well-known rocks on the shore near his house. There the shaman was welcomed by the people for he had been away a long time, and they wished to hear his stories again. But now he had a new tale to tell of the giant caribou, though never did he divulge the exact locality where the giant caribou guarded the cave where the animals sheltered through the winter.

In modern times less caribou come every year, and yet however widely the hunters search for the mysterious home of the animals they can never find it.

**96 Mythological hare-dog-seal and ptarmigan** by Peter Pitseolak. Drawing. From the Canadian arctic, 20th century. (Gimpel Collection)

So they have to seek for other means of living.

There are other little tales which explain natural things. Ravens are black because once upon a time there was a great feast, and the food was cooking on a fire of wood. The raven quarrelled with the owl who was giving the feast and the owl was so angry that he picked up the black charred wood and threw it all over raven so that he became black and never was clean again. The seagull and the raven challenged each other to a race to decide who would have most children. They set off round the course but the seagull was much more tricky than the raven and went around a shorter flight much more often. In the end the seagull won, and that is why white children, like the seagull, grew up into white people and took all the land for themselves. Which is rather an unkind story but also somewhat true.

The subject of folk tales occurs strongly in modern Eskimo graphics. In some cases drawings depict tales of the hunter and the intelligent bears; others tell of the use of magical charms which become dangerous. There are pictures of daily life and animals too. In many cases the details of the drawing are richly filled with stippling or hachures which give the effect of fur. Some drawings of women display the old favourite tattoo marks. In other cases the figures in the picture are black silhouettes with a few white lines to add details. These works are often stencils, cut from thin sheets of skin. They also appear as block prints made with hide printing blocks. The use of leather for blocks has some advantages in a certain softness of texture, and sometimes of a very slight surface patterning.

This printing from leather is a new art form which derived originally from skin outline figures exactly cut out and stitched as a kind of fur appliqué on seal or caribou skins. This is used nowadays for ornamental garments, and for fur mats and wall hangings. It is naturally an art form made by women, because in the past a woman's life was linked closely with the home, where she spent much of her time making beautiful fur garments from the skins brought home by father as clothing for the family. In the old times this work was done outdoors in the summer, and on calm days the seamstress was often dressed only in her boots so that the sun should bring pleasure to her naked body. Alas, as some Eskimo pictures show, the ladies too often became the victims of ravenous mosquitoes.

The minuscule art of old times was worked in ivory, often engraved, and in local stones: slate, steatite and serpentine. Nothing was large; a walrus tusk was quite the largest surface to be carved. Most of the product was very personal and private because it contained individual magic brought from within

by the artist. But now that there are international markets and a real demand for high quality work a larger variety of size occurs. Boulders of the right stone are sought out, and often they are found most easily by prospecting the coast for stones of about the right size. The surface quality and colour of the stone is most easily seen below water and many artists go with friends on prospecting journeys to find stones to bring back on the sledge to work at in the local trading co-operative workshop. Another source of attractive material is the ancient house ruins found here and there which were made by the Tornrit of the Dorset culture. Here are whale ribs and great vertebrae as well as the occasional massive walrus skull. The old bone is usually weathered to a dull surface of light grey, and in most cases the cancellar tissue is exposed to give a most attractive surface, though not a pleasant one to handle. However, these natural forms belonging to the Eskimo past seem to suggest ideas to the artist, so that in this material many

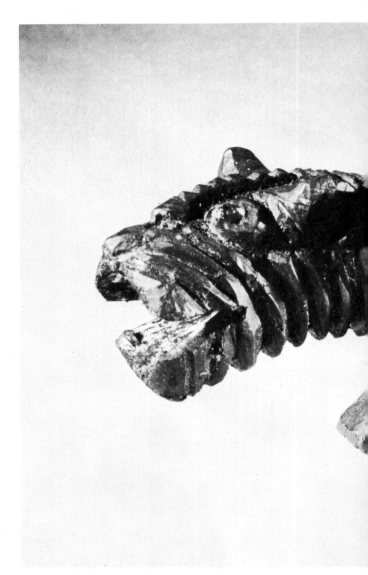

strange spirit beings take form, and menacingly emerge from their long sleep in the unconscious heart of the people. Sometimes a frightening torngak will emerge. He is a spirit at once human and animal, but never truly human; his mind is turned to mischief and trickery so he is grotesque and menacing. His happiness is to cause trouble, to wreck a kayak, to make a whale destroy its hunter, to cause the ice floe to crack and drown people, or to start sudden storms. The torngak is not pleasant, but he is an expression of the real uncertainties of life in the arctic; he is the archetypal trickster seen as many beings of ambivalent character. However the same artist who will make a torngak one day will at another time use a similar block of material to make an Eskimo hunter trudging home with a captured seal behind him, or a fine fox on his back.

Many modern works of Eskimo art have been made in the haven of Christian missions, but they are rarely on Christian themes. They also tend to show Eskimo life in one aspect or another. If a biblical story is incorporated in a carving it is put very properly in Eskimo terms. An Eskimo interpretation of the calming of the tempest on the lake, the miracle of the loaves and fishes, or the resurrection of Lazarus may seem strange to the white man, but they are all the more real to the artists when the story is stated in terms of Eskimo life and not copied from a nineteenth-century Bible picture. Nevertheless, we can expect to find more expressions about animals and family life than anything else. The surrounding of deep affection is very clearly felt. The family in its thick furs, clustered altogether in companionable unity, is as common as the mother with the child nestling in her hood, put there for warmth and cuddly comfort. Similarly, even the quarries of the hunter are shown as living, sentient beings, regarded with that

**97 Skeletal tupilak** with human feet and spirit faces in its shoulders. Wood (15.4 cm long). From Angmagssalik, Greenland, about 1900. (Danish National Museum, Copenhagen)

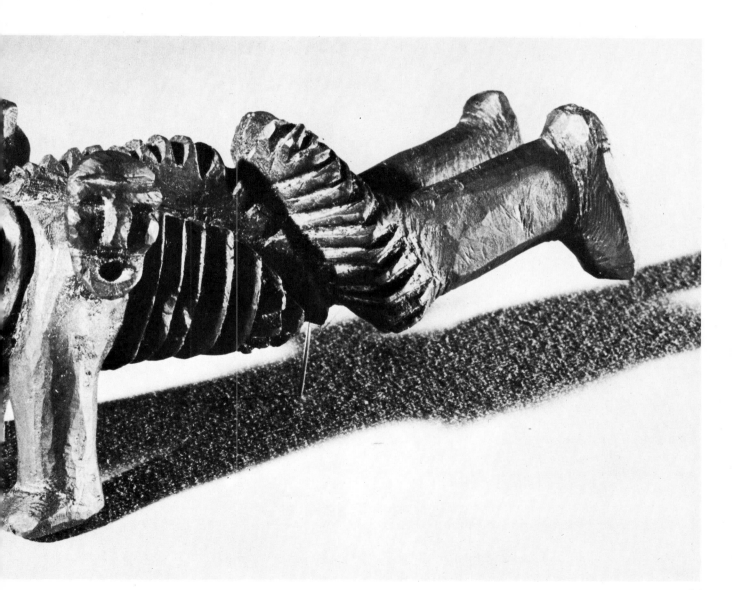

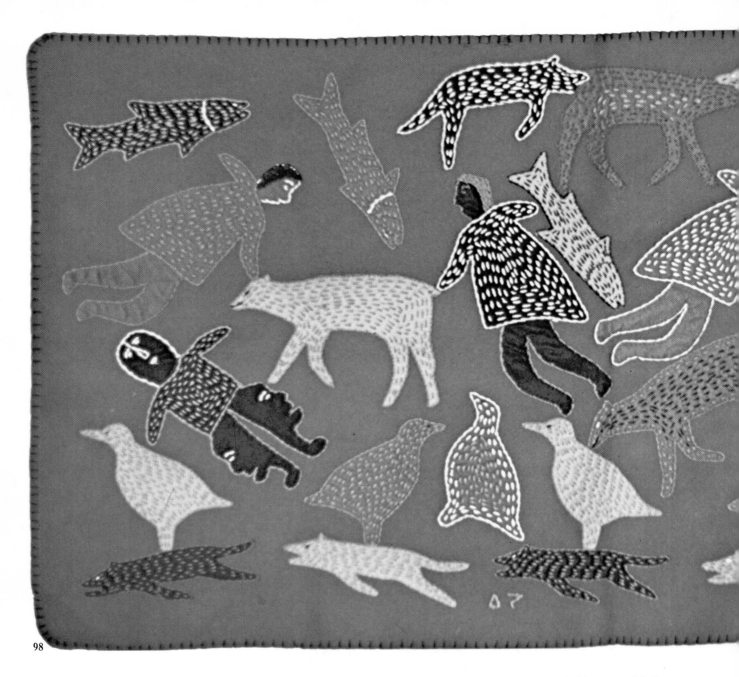

understanding which marks true affection. Because that traditional Eskimo life has never totally disappeared, the spiritual link between human and animal has never been quite broken.

The products of modern Eskimo artists remain based in the life of the Eskimo people. An artist may make use of a traditional idea, and yet say something fresh in a new medium. It may be that the critic can see only the animal or the pattern as something graceful and well executed, but the artist can see an expression of local life, or an ancient folk tale or even an actual historical event. A scene of a crowded whale-boat carved in steatite, records a famous migration in search of food which took place in about 1912. The artist remembered the names of many of the people involved.

The simple music of the Eskimos, with its traditional songs and dances to the thunderous music of the huge tambourine-like drums, is now replaced by tapes played on a transistorised recorder. But the festivals held at traditional times, the old days for starting sea hunting or for returning to the land, persist and old songs mix with modern whenever a drum dance can be arranged. There is a descent from the past, but it is partial and the old atmosphere of magic has gone; yet the occasions are ones in which a skilled dancer can give an acrobatic performance and a juggler mystify the audience much as he might have in ancient times. On such occasions people are happy and free to talk and sing as a community. Here hopes are discussed and sorrows condoled. The Eskimo community sense has not diminished, and, while

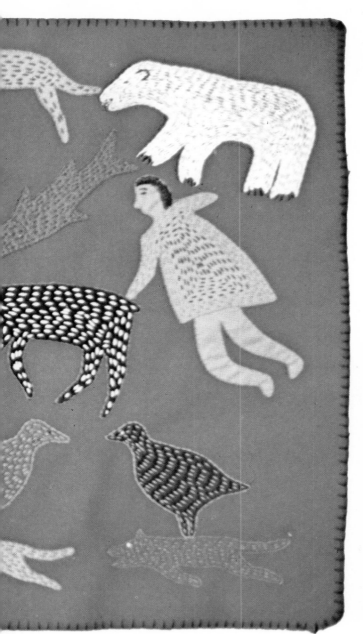

**98 Wall hanging** by Naomi Ityi showing scenes from Eskimo folklore. Appliqué on wool (71.5 × 107 cm). Baker Lake, N.W.T., 1971.

**99 Wall hanging** by Irene Avaalaqiaq. Appliqué on wool (132.5 × 142.5 cm). Baker Lake, N.W.T., 1971.

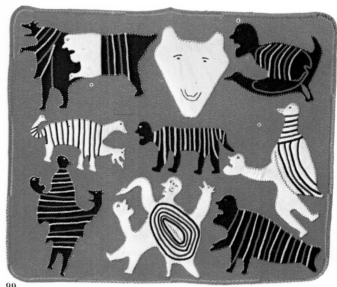

99

dancing and music are arts in themselves, they also provide material for the visual arts either in sculpture or graphics.

But beyond the festivities and the new economic life the vastness of the arctic still enfolds the Eskimos. They do not wish to desert their land; it is in some ways a parental home for all of them, and its dangerous beauty is a matter of deep affection among them. Even in the most advanced groups there are times when the people prefer to go out in their summer tents to hunt and fish in something like the old way, or at least the way of their grandparents. Boys still play at hunting and know many stories of the adventures of the old time hunters. For three thousand years the Eskimos have endured the rigours of arctic life. Their art, even at its simplest, stands for their

indomitable courage and capability in the face of adversity. Yet today the whole rhythm of arctic life is threatened by an enemy more terrible than nature. Supplies of game have steadily decreased, the ocean is overfished, the whale, the polar bear, the walrus and the musk ox are all in danger of extinction. And the curse of pollution has fallen in these remote lands. The struggle for survival continues, but now man is the enemy. The Inuit, the 'people', have much to teach us when it comes to the condition and behaviour of man. Hopefully, through their art, they will succeed and will survive as themselves in the modern preliminary to the Aquarian age.

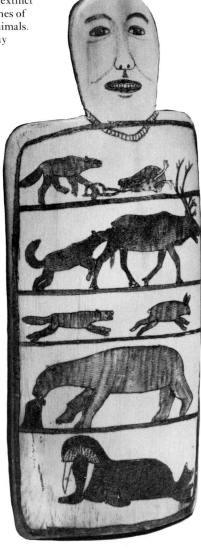

**100 Flour scoop** made from extinct mammoth ivory with scenes of fox trapping and other animals. (Collection: Hudson's Bay Company)

# Index

Numbers in **bold** type refer to illustrations

## Some further reading

Bandi, H.G., **Urgeschichte der Eskimo**. Stuttgart, 1965

Birkett-Smith, K., many books, but general work is
 **The Eskimos**. Copenhagen and London, 1936

Burland, C.A., **Men Without Machines**. London, 1967

Caillois, R., **Chefs d'œuvre des arts Indiens et
 Esquimaux du Canada**. Paris, 1969

Canadian Department of Northern Affairs and National
 Resources, **Canadian Eskimo Art**. Ottawa, 1956

Canadian Eskimo Arts Council, **Sculpture of the Inuit:
 masterworks of the Canadian Arctic**, exhibition
 catalogue. Canada, 1971

Carpenter, E., **Eskimo**. Oxford and Toronto, 1959

Collins, H.B., 'Prehistoric Art of the Alaskan Eskimo',
 **Smithsonian Miscellaneous Collections**, Vol. 81
 no. 14. Washington 1937; 'Archaeology of St. Lawrence
 Island, Alaska', **Smithsonian Miscellaneous
 Collections**, Vol. 96 no. 1. Washington, 1937

Danish Anthropological Society, **Folk**, periodical.
 Copenhagen, 1964 ff.

Dockstader, F.J., **Indian Art of North America**.
 Greenwich, Connecticut, 1966

Haberland, W., **North America** (Art of the World).
 Baden Baden 1964, London 1968

Himmelheber, H., **Eskimokünstler**. Eisenach, 1953

Hoffman, J., **The Graphic Art of the Eskimos**,
 U.S. National Museum Report for 1899, pp 739–968

Holtved, E., **Eskimo Art**. 1947

Hudson's Bay Company, 'Eskimo Art', **The Beaver**,
 autumn issue 1967. Winnipeg

Jenness, D., various **Reports of the Canadian Arctic
 Expeditions**. Department of Mines, Ottawa

Judson, K.B., **Myths and Legends of Alaska**.
 Chicago, 1911

Larmour, W.T., **Inunnit: The Art of the Canadian
 Eskimo** (in English and French). Ottawa, 1967

Larsen, H., and Rainey F., 'Ipiutak and the Arctic
 Whale-Hunting Cultures'. **American Museum of
 Natural History, Anthropological Papers**, Vol. 42.
 New York, 1948

Martijn, C., 'Canadian Eskimo Carvings in Historical
 Perspective', **Anthropos**, Vol. LIX. Fribourg, 1965

Meldgaard, J., **Eskimo Sculpture**. London, 1960

Rasmussen, K., **Across Arctic America**

Ray, D.J., **Artists of the Tundra and the Sea**. Seattle,
 1961; **Eskimo Masks, Art and Ceremony**.
 Seattle and London, 1967

Swinton, G., **Eskimo Sculpture**. Toronto, 1965

Thule: (various authors) **Reports of the Fifth Thule
 Expedition, 1921–1924**, in 10 volumes.
 Copenhagen, 1927–1952

Williamson, R., 'The Spirit of Keewatin', **The Beaver**,
 summer issue, 1967. Winnipeg

## Acknowledgments

The museums, galleries and private collectors listed in the
captions demonstrate the generous help we have received
from many friends around the world. In particular we are
grateful to the late Charles Gimpel for permission to
photograph so many beautiful things from his private
collection, to the Canadian Eskimo Arts Council for
permission to photograph their exhibition during its short
stay in London, and to the Hudson's Bay Company who
allowed us to photograph their collections just before they
returned to Canada. The British Museum, in its special
section, The Museum of Mankind, has also given us
considerable help in allowing us to take photographs at very
short notice. From everyone whom we have asked for
assistance in illustrating this book we have received
unstinting help. We only hope that their generosity finds
some small reward in the use we have made of their
material in these pages.

## Sources of photographs

American Museum of Natural History, New York 8, 56;
Anthropological Museum, University of Aberdeen 68;
K. J. Butler, Winnipeg, Manitoba 98, 99; Canadian
Eskimo Arts Council, Ottawa, Ontario 2, 3, 10, 14, 27, 37,
44, 72, 82, 86, 89, 90, 94, 95; Cincinnati Art Museum,
Cincinnati, Ohio 38; City of Liverpool Museums 46;
Danish National Museum, Copenhagen 75; Hamlyn
Group–Hawkley Studio Associates 5, 15, 16, 17, 18, 21,
23, 25, 30, 31, 32, 40, 42, 47, 48, 54, 55, 58, 59, 60, 65, 67, 69,
70, 71, 76, 79, 83, 84, 85, 88, 91, 92, 93, 96, 100; Hamlyn
Group Picture Library 19, 26, 29, 34, 35, 41, 50, 52;
Jørgen Meldgaard, Copenhagen 4, 6, 11, 12, 13, 39, 43, 73,
74, 97; Hugh M. Moss Ltd., London 1, 20, 28, 80, 81, 87;
Museum of the American Indian, New York 22, 33, 53;
Museum of Mankind, London 36, 49, 51, 57, 63, 64;
Museum of Primitive Art, New York 9, Royal Scottish
Museum, Edinburgh 61, 62, 66; Smithsonian Institution,
Museum of Natural History, Washington, D.C. 24;
University of Alaska Museum, College, Alaska 7, 45, 77, 78.

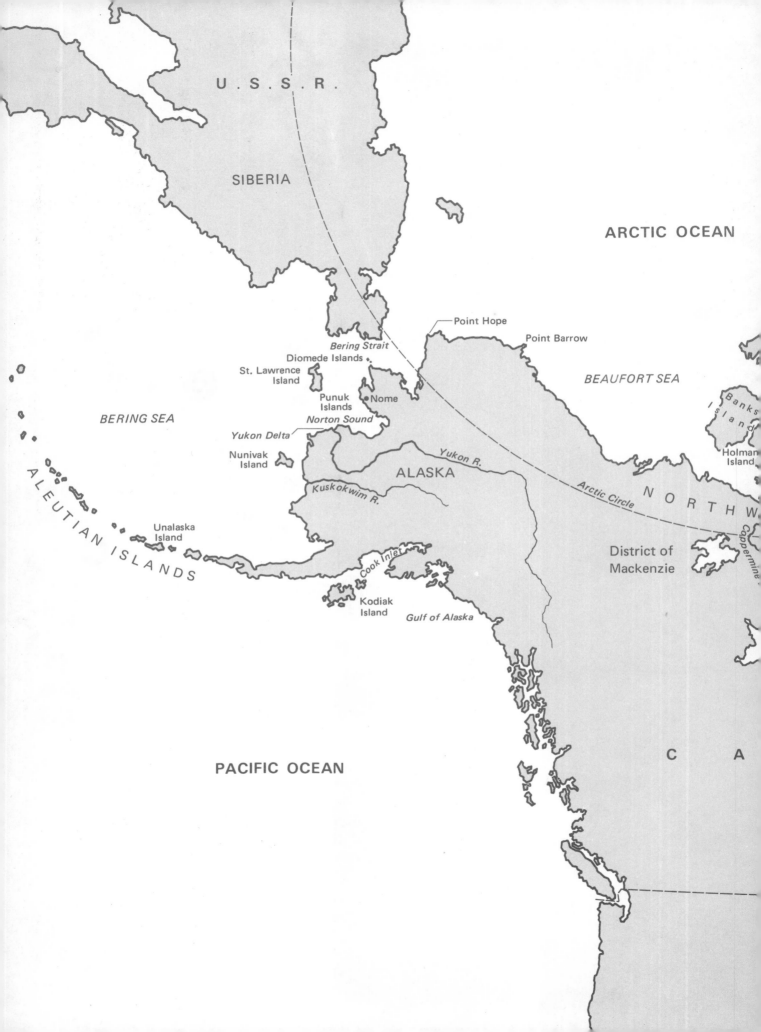